SIGNAL:01

Signal:01, edited by Alec Dunn and Josh MacPhee
© 2010 PM Press
Individual copyright retained by the respective contributors.

ISBN: 978-1-60486-091-7
LCCN: 2009912459

PM Press
POBox 23912
Oakland, CA 94623
www.pmpress.org

Design by Alec Dunn & Josh MacPhee/Justseeds.org
Cover illustration by Melanie Cervantes
Cover design by Alec Dunn & Josh MacPhee/Justseeds.org
Frontspiece photo by Impeach

Printed in the United States.

Thanks to all at PM Press, all at the Kate Sharpley Library, Grrrt, Jos, Moe Bowstern, YNKB, Tom Civil, and Jerry Kaplan.

SIGNAL:01

SIGNAL is an idea in form

It is a response to the myopia of contemporary political culture in the United States, our blindness to most things beyond our national boundaries, and our lack of historical memory. There is no question that art, design, graphics, and culture all play an influential role in the maintenance of the way things are. They have also been important tools for every social movement that has attempted to challenge the status quo. The production of art and culture does not happen in a vacuum; it is not a neutral process. We don't ask the question of whether culture *should* be instrumentalized towards political goals, the economic and social conditions we exist under marshal all material culture towards the maintenance of the way things are. The question we need to ask is whether our cultural production is used to uphold the massive levels of inequality that exist across the globe, or to challenge capitalism, statecraft, patriarchy, and all the systems used to produce and reproduce that disparity.

We welcome the submission of writing and visual cultural production for future issues. We are particularly interested in looking at the intersection of art and politics internationally, and assessments of how this intersection has functioned at various historical and geographical moments.

Signal can be reached at: editors@s1gnal.org

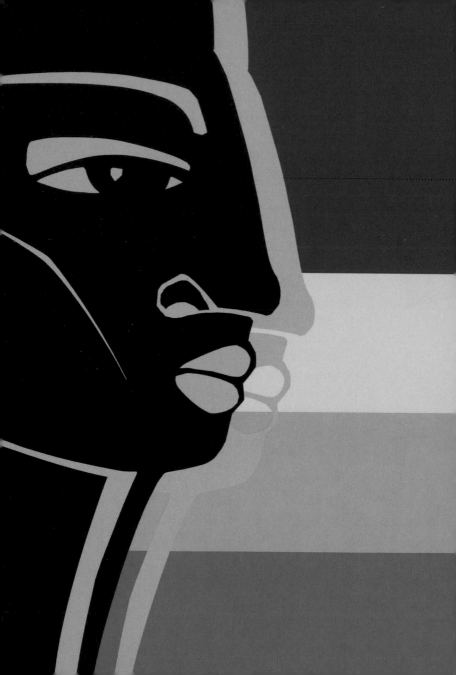

TALLER TUPAC AMARU

THE FUTURE OF XICANA PRINTMAKING

Founded in 2003, the Taller Tupac Amaru is a printmaking collective made up of Favianna Rodriguez, Jesus Barraza, and Melanie Cervantes. Their mission is to create visually powerful screen printed political posters to be used by social movements. In the past eight years they have produced hundreds of posters and graphics used for a wide range of social justice struggles, from Palestinian liberation to anti-gentrification, immigrant rights to Indigenous solidarity. All three members were interviewed by Alec Dunn and Josh MacPhee in the Spring of 2009.

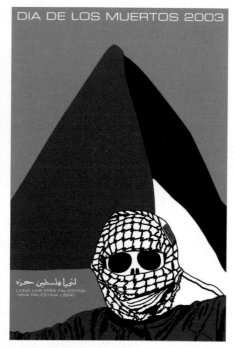

DIA DE LOS MUERTOS 2003

لتبيا فلسطين حرة
LONG LIVE FREE PALESTINE!
¡VIVA PALESTINA LIBRE!

What's the history of the Taller?

Jesus Barraza: In 1998 Favianna took a class at UC Berkeley with Yreina Cervantes, who asked her to take part in a screen print portfolio at Self Help Graphics in Los Angeles. Favianna's idea was to digitally create color separations for her print. She asked me to help and the two of us set off on figuring out how the hell we would do that. We took her drawings, digitally reproduced them, and we color separated this nine-color print using Illustrator and QuarkXPress. We did it totally wrong, but we did it. And it was right after that, in the parking lot of Self Help Graphics, that we first talked about having our own studio. About three years later, I got a job at the Mission Cultural Center in San Francisco as a graphic designer. Part of my job was to design the screen-printed

posters for their exhibits. That's how I got involved in screenprinting and then it jumped from there.

While I was at the Cultural Center we pretty much had free reign of Mission Grafica (the printmaking studio housed there), but once I left we had nowhere to go. After that I started working with Favianna at the graphic design business her and Estria Miyashiro were running at the time, called Tumis. There was an idea to start a T-shirt arm of the business, so we set up this T-shirt screen print studio. And that's where the Taller was born.

Favianna Rodriguez: One of the reasons that we were able to get materials cheap was because all these older printers, our mentors, were no longer screen printing or they were going digital, trying to embrace new technologies. We were already working in these new technologies, so

we were really trying to set up a space where we could print by hand. All this equipment was lying around, and we took it and set up our studio.

Because we were already running a design firm we were almost immediately making posters for community and political organizations. We can definitely outsource posters to offset printers, but often groups need things faster, cheaper, in small runs, or that aesthetically are more like propaganda posters. Screenprinting became one of the design options that we offered. When you get hired as a designer it's a really interactive relationship where you have to follow what the client wants, but when it's a collaboration between an artist and an organization, we have more of a chance to have an artistic voice. And we can get much more radical.

JB: On my end, I had done a few jobs for people or organizations where I

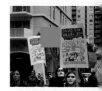

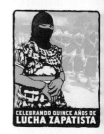

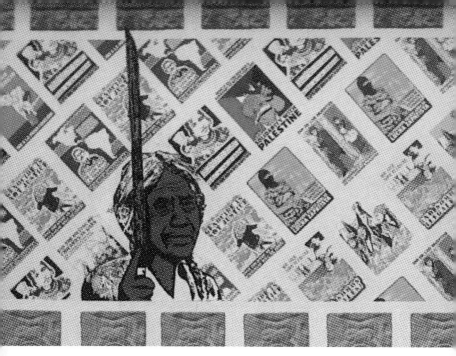

designed posters for them and had them offset printed. But I didn't really have the money to print large runs of my own posters in offset, so screen-printing was about being able to find my own voice: posters that just really came out of a raw idea that I had about the Zapatistas, or Angela Davis, or Palestine, or about something that was going on in the Mission. It was really an opportunity for me to voice my opinion and put myself out there in a way that I had never been able to do before.

How did you originally meet?

FR: We met in college in 1996.

JB: I was at San Francisco State, but living in Berkeley because both of my sisters were at UC Berkeley, living off-campus at Casa Joaquin Murrieta, a Chicano co-op. They moved out, but got me housing there. I started working on *La Voz de Berkeley*, a newspaper that my sister had started a few years back, which was an oppositional Xican@ paper. That's how I got involved in UC Berkeley campus politics.

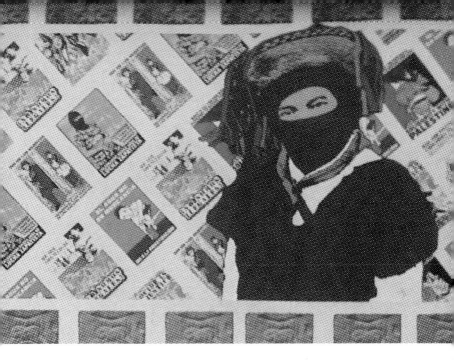

FR: The co-op was a place where a lot of Xincan@ activists lived and worked and there was history there. In 1999, the Third World Liberation Front, which had originally been organized in the 1960s, was reborn, and led student strikes and hunger strikes because the school was trying to cut the Ethnic Studies Department. Jesus and I had already been collaborating and living in the same space, and we were going in the same direction, towards media, technology, and arts. So when the hunger strike happened we coordinated the media and cultural support, like fliers and the newspaper. It was really significant because it meant that we would write, develop art, and do graphic design together. We would teach each other stuff. Jesus taught me how to design. Marco Palma taught me how to write web code. All this skill sharing was happening around media production.

JB: Our first collaborative effort was called Ten12. It was an artist/techie collective made up of Favianna, myself, Marco, and Jose Lopez. We had the idea of making art and websites and working

on tech-based projects. It was the late '90s, so the web was really new. That was the first iteration of our collective work, which eventually turned into Tumis and the Taller. It's been an evolution.

What were you doing at this time, Melanie?
 Melanie Cervantes: I was being exploited! (*Laughter*)
 I was working. My trajectory is a little bit different than Favianna or Jesus. I wasn't

WE RISE

tracked to go to university out of high school. I worked for five or six years before I came to the point where I was like, "This is so fucked, I'm really skilled and it doesn't seem to matter: men get promoted above me, people that don't have the same skill sets get promoted above me, white folks get promoted above me." I was working in retail and in the fashion industry, and really was only able to survive because I was doing custom clothing for folks.

I loved color, but being able to express myself was more utilitarian and more of a way to support myself. It wasn't until I went back to community college and started doing organizing and cultural work for campus organization that I started using art as a creative tool, but I didn't think I was an artist; I was just making "stuff." I was doing community work and doing what was right. I didn't have political ideology and I didn't have the experience to

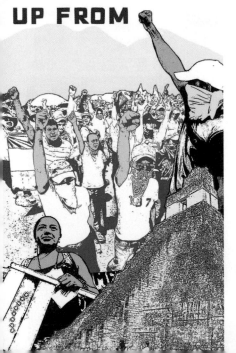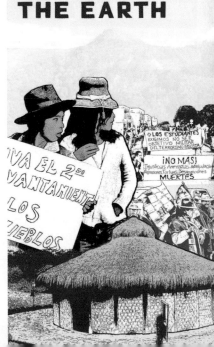

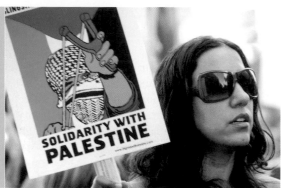

OAKLAND: EAST SIDE STORY
YERBA BUENA CENTER FOR THE ARTS OCTOBER 28 - DECEMBER 31 2006

SOLIDARITY WITH
PALESTINE
www.fsprojectphoto.com

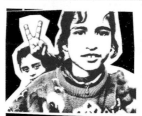

QUEREMOS
Un mundo en el que
caben muchos mundos
ALTO A LA GUERRA
PAZ Y DIGNIDAD

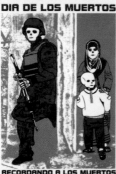

DIA DE LOS MUERTOS

RECORDANDO A LOS MUERTOS
DE LAS GUERRAS INJUSTAS

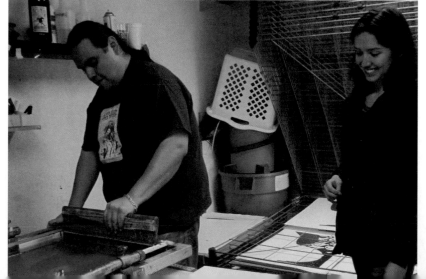

name what I was doing. As I finished the two years I needed to transfer to a bigger school, I really came to see that I wanted to pursue ethnic studies. When I got there it took me awhile to embrace being an active agent of change and an artist. It was only after the encouragement of a Xicana artist, Celia Herrera Rodriguez, who really pushed that identity. She was like, "You've been doing this, you just haven't named it."

So I really started my art practice doing fabric, textile work, and stencils. The fabric work really came out of Celia pushing her students to do what they knew, and I was like, "Well, I learned sewing from my mom, and my mom learned it from her mom, and her mom learned it from her mom." It's a generational thing, and a source of empowerment, this ancestral passing down of doing work that talked about being an Indigenous Xicana. At the same time, I was seeing a lot of stencils online and seeing that a lot of the stencil artists in the Bay who were well known were white men, and I thought, I can do that too as a Xicana. So I

started at first by printing out other people's stencils and figuring out how to cut. I was doing campus organizing around Proposition 54, the racial privacy initiative in California that would ban the collection of racial data, which was a campus issue. I started printing all these stencils to raise awareness. I look back now and see they're not the greatest stencils, but it was my introduction to making reproducible art.

At this point I had actually seen Favianna's and Jesus's work but I hadn't met them. I met them when my employer hired Tumis to design business cards. A year later Jesus and I were dating. I was producing work, big painted banners that had the graphic style of posters. Jesus sent images of my work to Favianna and she was like, "She should be in the Taller." That was a few years ago.

FR: A lot of us Brown and Black folks are not trained in art school, but end up in college and take ethnic studies classes if we can. Chicano artists are not getting hired at art schools, they're getting hired to teach seminars at universities, so we

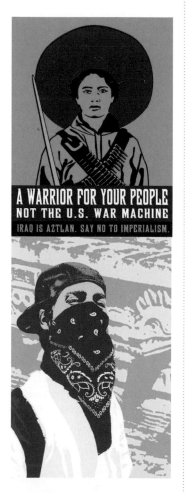

A WARRIOR FOR YOUR PEOPLE
NOT THE U.S. WAR MACHINE
IRAQ IS AZTLAN. SAY NO TO IMPERIALISM.

get pulled into the arts though this back door. This is one of the only ways we can engage with professional artist of color. The reality is that there are not enough Chicano, Latino, and Black printmakers.

I teach a lot of white kids how to do linoleum block printing because of the places I get invited to teach. But when I teach youth of color, there's a whole other layer of commitment because, again, these young people are probably not going to go into an art career. One thing we've been struggling with is that we don't get to mentor a lot of youth that look like us. We always try to be good mentors, but sometimes it feels like we're only one tenth the mentors we had.

MC: Yeah that's a huge challenge. How many one-off workshops do we do where we give a general introduction, but we can't ever really get deeper into it? How do we go beyond the one-off workshop? Even if it's a seven-day workshop or a three week workshop? We're gonna try and experiment with doing some internships and apprenticeships so we can try and go more into depth. We don't have a huge infrastructure. We really operate from a few seed grants and mostly out of pocket. The models

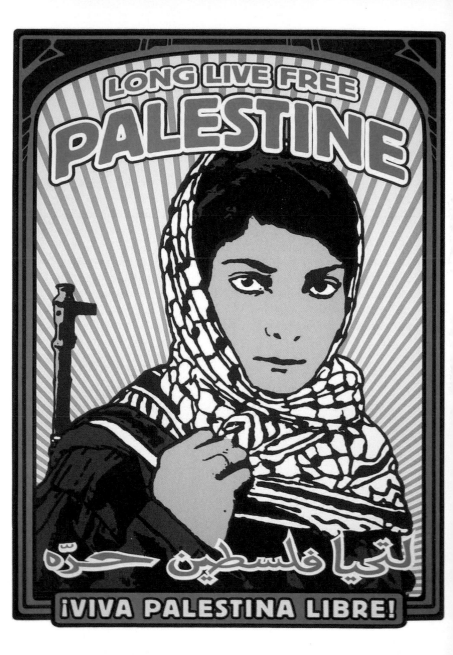

LONG LIVE FREE PALESTINE

لتيا فلسطين حرّه

¡VIVA PALESTINA LIBRE!

we're trying to build and learn from have to be better than the non-profit model, we need to look at groups like OSPAAL (Organization in Solidarity with the Peoples of Africa, Asia, and Latin America) in Cuba and the TGP (Taller de Gráfica Popular) in Mexico.

You mentioned the Third World Liberation Front and the 1969 student strike. Rupert Garcia, Malaquías Montoya, and the origins of the modern Chicano printmaking movement came out of these strikes. Mission Grafica had also been a hotbed of political printing in the 1980s. Were you aware of this history? How do you relate to it?

JB: I was lucky because I had two sisters who went to college and every year after my first year of high school my sisters would bring back their books, so I was reading Karl Marx, but they also brought back the exhibition catalog for "Chicano Art: Resistance and Affirmation (CARA)," this big art show that happened in the

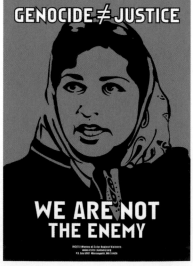

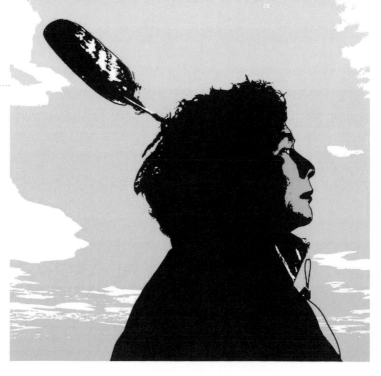

INDIGENOUS PEOPLES THANKSGIVING

ALCATRAZ

CELEBRATING 40 YEARS OF THE
AMERICAN INDIAN MOVEMENT

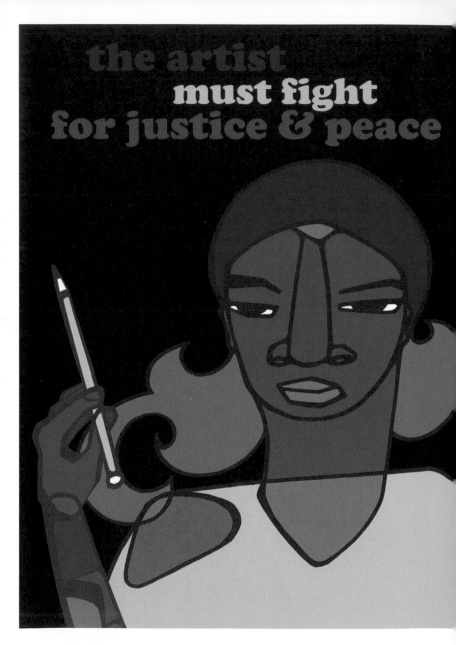

late '80s. It was an exhibition that had toured big museums, that was where I first learned about Rupert García, Esther Hernández, and Juan Fuentes.

FR: As far as collectives, when we first started organizing we looked up the points of unity of Inkworks, which is a collectively run offset printshop. I also recall referring back to Justseeds. Remember, in the late '90s there was hardly a web presence for anyone. It was not until 2004 or '05 that our mentors were even thinking about the web. All that information was gathered through word of mouth: Mission Grafica, the Center for the Study of Political Graphics, meeting Lincoln Cushing, meeting Emory Douglas, we'd meet these people and be like, "Ooh, cool."

But looking back on a lot of older projects, they were running in a way that was unsustainable, they were either on the verge of collapse, or would close their doors in the next five years. When we started Tumis, it was different because it was a for profit operation. We learned that we needed to have a business side of things. We needed

to think about the long term, things that were sustainable. Things like what Amiri Baraka or Emory Douglas formed, these informal artists collectives didn't survive long enough to get passed on to us as the next generation, except as stories.

JB: All of a sudden in the 1990s, there was just this disconnection; everything got fucked up and screen printing really slowed down in the Chicano community. I remember working at the Mission Cultural Center and Yolanda Lopez coming up to me and being like, "This whole thing is being passed down to you. You are the next generation." Having that kind of love from these older artists, it just breaks my heart every time.

I get the impression that you had to track down this older generation. Are you trying to keep open connections to a younger generation to avoid those problems?

FR: I grew up here, and actually, before I was born, Malaquías Montoya had a print shop on the next block, here in Fruitvale (Oakland). I was

being trained by people who'd been in the mural arts movement. Like the artist Andres Galindo, who gave us our screen printing equipment, he was actually my teacher when I was nine. They did help me, but it was really one class at a time, and then I didn't see them for months and months, and it was at whatever center was operating and could fund them to teach those classes. So I would help on a mural or I would cut the image for a screenprint, usually at an inadequate space because having an art class was the last priority! "First we have to have all the gang violence stuff and then safe sex classes and then . . ."

I remember once being only one of three students, so sometimes the classes would get cancelled. And there is the question of economics. Now at the East Side Arts Alliance, we have a big debate because we started a mural arts program and so we get all these youth, and even if we train them really good, they need jobs and we don't have a way to plug them into an infrastructure for jobs. And sadly at times the only viable thing to

do is to try to send them to art school, but we didn't go to art school. We would have them for four or five years and at some point they'd be like, "What's up, Favi, give me a job!" and there's nowhere to plug them in. That's a problem arts organizations

XICANA

have, there's not a job market for youth, unless you teach them how to be entrepreneurs, which is a whole other task. I think we can do that, but how do we tell them to go into our field of work when you know they're not going to be able to get jobs?

MC: At all these talks we give, we say, "This is what we do after we work a full day

doing something else." Then they're like, "Oh shit." I worry that they're not gonna want to do it. It takes a real commitment.

FR: And actually Jesus and I don't work full time, so that's something that we're able to do because we work for ourselves, so we can be very very flexible. But it's very hard, cause if we're not making money at Tumis, we cut the money from our paychecks. I feel like we're saying we have to work eighty-hour weeks. But that's the wrong message to tell people when we're trying to fight capitalism! We need to rethink this.

JB: We can't just expect people to be artists. For a lot of people in our communities, it's hard to just be an artist. You can't just do it that easily. It's complex. It makes me feel kinda contradictory to the stuff that we preach.

How do you feel like this ties back into the politics in your work? In many ways the root of this problem is economic; none of us can

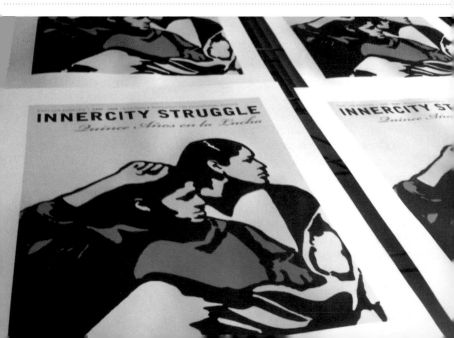

actually grow up and do the things we aspire to do under capitalism. Now the idea of "community education" is being used to change the definition of an artist to be someone who teaches kids to become entrepreneurs. But we all know that if every kid on this block tried to start a business, they're all gonna fail; the system doesn't work. How do you struggle against this?

MC: It's interesting because the fortieth anniversary of the Third World Liberation Front happened last week, Favi and Jesus were on a panel with someone from 1969 and someone from the Anti-Apartheid Movement in the '80s. It's a trajectory of folks over many years who were fighting and using the framework of Third World Liberation. When I think of all the liberatory movements that I represent in my art, they're just specific examples of resistance to the multiple oppressions entwined in capitalism, right? What does it mean to imagine a society that looks differently?

I could be doing a million other things in terms of content, but making that conscious decision every time is about thinking of a future where young people might look back on this as their history and hopefully be living in an economic system that is not going to destroy the world.

JB: A long time ago I figured out that shit is not gonna get better for Indigenous people on this continent in my lifetime. 1992 was the quincentennial of the beginning of the cultural invasion where our people have gone through cultural genocide. It's taken us 500 years to get to this point, our lineages, our histories, and the things that have been passed down to us. So after the first 500 years, there's gonna be the next 500 years. I see myself as part of that first generation of that next 500 years coming up. A lot of this stuff is throwing stones. The art we're creating is like throwing little stones at a wall, and as we keep going it's gonna weaken and it's gonna break. Were not trying to be the solution, it's a multi-generational movement that we're a part of. It's not that much, but we are able to pass this on and get a few more kids throwing

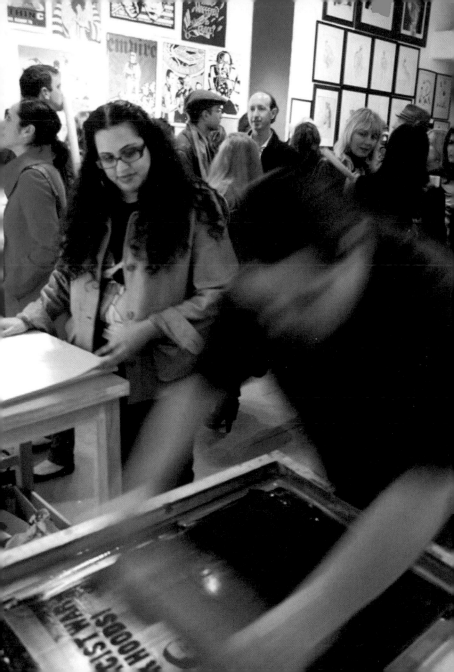

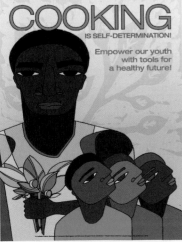

stones. Eventually it's all going to tumble down.

FR: I also think what we're experiencing is something universal. I used to think what was happening to me or what I was seeing was contained to this neighborhood or this state. Then I started understanding it was a national problem and then after I started traveling I started understanding it was an international problem. I think that people all over the world are very hungry to understand what's happening to them. It's something I experienced as a high school student. I met a lot of the people who mentored me to be an activist; they reached out to me when I was an early teenager. I was really angry, and they helped me funnel my rage. It helped form my political ideology to be a freedom fighter. There's ways to inspire people to do that. When I look back on this, I saw some men of color, but I never saw women of color as freedom fighters. So when I go out and talk, I'm looking to reach out to those young girls that are feeling very insecure, or the system is telling them how ugly they are, all this shit. My goal is to help them love themselves.

I remember seeing Yolanda López's *Who's the Illegal Alien, Pilgrim?* poster, and I was like, "Whoa, that is strongly challenging white supremacy." I wanted to hide it, cause I was afraid if a white person saw it they'd yell at me. But that was my first experience challenging white privilege, and it was through art. So I see that there's power in us as artists. I agree with Jesus, it may not happen in our lifetime, but the key thing is we're planting seeds, especially with young people.

How did you get started making art?

FR: My parents didn't want me to make art. The values we've been indoctrinated with are that success means being a doctor, or a lawyer, or something "meaningful," something that could make you "proud of coming to America." After I dropped out of college, my parents were very upset and encouraged me to go back to school and be a gynecologist or an architect.

My parents were supportive in some ways, I don't want to say that they weren't, but they were also trying to survive in this country. They needed their children to help them survive.

MC: I grew up pretty thrifty and poor. My mom sewed all of our clothes. I didn't own a piece of clothing that wasn't made by my mother until I was sixteen. The luxury that I had when I was a kid was to choose my fabric. I like to think that I learned color theory from my mom. My dad worked as a paper box printer. He did it as labor, not as art. So when Halloween came around and I needed a costume he brought a paper box home and we painted it. I was dressed as a popcorn box, and my mom made popcorn out of fabric. All these things were done by necessity, but were so creative and beautiful. My parents were my first teachers. My family was the backdrop, and then books, more then anything, were vehicles for learning about other artists and art work.

JB: My sisters took me to this art exhibit in L.A. that was called "Thirty Centuries of Mexican Art." It was huge. It was the first time I saw Diego Rivera's and José Clemente Orozco's paintings. Then I started working on my high school newspaper. I was the lay-out guy, the one who worked on the computer. That was what really got me

going towards art. When I was in college I was studying ethnic studies, but I was also becoming a graphic designer, and my folks didn't really know what that was; it's hard to explain or show. I would bring them a newspaper and be like, "I laid this out!" and they'd be like, "So? Uh. . .OK." It became more tangible when I started bringing prints home.

Do you have examples of posters and graphics that you've worked on that you feel were effective?

JB: The one big example I can think of is the young man shot by a cop at a BART (Bay Area Rapid Transit) station. Early New Year's day in 2009, around 4 a.m., there was a scuffle on the train, and the BART police came and pulled everybody off. Somehow this crazy cop ended up pinning this kid, Oscar Grant, to the ground, pulling out a gun, and shooting him in the back. There was a huge movement that started up around this, against police brutality. Melanie and I heard about it, and we came home that night and brainstormed ideas for the text, and

talked about images. We had an image of Oscar Grant, but in the background we also had an image of the Israeli invasion of Gaza and the mass graves of Palestinians, which was happening then as well. We wanted to draw a parallel between these two things happening. So we screen printed posters and made picket signs for the first protest. We brought them out and distributed them, and we also put it out on the internet. And that was one of the biggest reactions I've ever seen with anything we've been involved with, people really vibed on it, and it spread like crazy.

MC: We had two measures of effectiveness with that poster, one was with how widespread it got. The image had a life on the web, not only on the streets. Also the Grant family really embraced it, they were overjoyed and thankful, I was so moved by that. The second was that we saw all these right-wing sites carrying the image. They were really threatened by the text on the poster: "End Government Sponsored Murder."

The TGP had systems of group

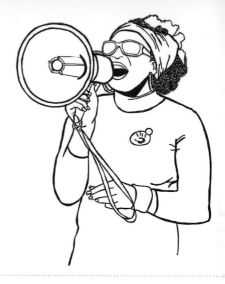

critique, and I know you all work with organizations in a similar way that the TGP did. A union would come to the TGP and the artists would collectively decide on imagery and who would be the best person to do the work, they had a system of working out ideas. How much internal dialogue do you three have about the work that you are doing, and how you represent issues and people?

FR: I think there are a few organizations who see posters as powerful tools. That's not a huge amount, but with every poster we bring new ideas into play. Someone will see a poster and say, "That's super tight, can we make something like it for our cause?" I always try and get us a little money for it because we need it. We've done so many free posters, you could do free posters every day for the rest of your life. I think that if there was a growing network of organizations who saw the value in what we do and wanted to support propagandists it would be great. But realistically, with all the money that is being cut back from government funding and foundations, that is the last thing they are thinking about. Organizations value certain things but don't attribute that same value to artists. They'll pay for other things, but not art.

When I make posters I really ask the groups to help me with the messaging. With the immigration rights posters, we sent all the

text to the organization, they helped translate it and gave feedback. For example, they'd say, "We shouldn't say 'we are not criminals,' because that's implying that we're the model minority, we're Mexicans, we're not like those Black criminals." And I hadn't even noticed that, so it was really helpful to us.

We were thinking of how to change the conversation around immigration. The framing that we're bombarded with is around *illegal immigration*. The word illegal is only used around immigrants, when other people break the law, like this Madoff guy, he wasn't called an "illegal investor." We're reframing things, we're saying immigrants are remitters, they're remitting so much money back to their home countries, like Mexico, El Salvador, and Guatemala, that it has become the number one or two import. That's huge economic power. So why not reframe immigrants as a very powerful economic force, or reframe the idea that if capital is able to cross borders, why not workers?

There's a feedback loop there, and that happens a lot with posters. People will suggest messaging, and then there's a dialogue. One thing we can do better is time management. We don't have enough time, we're just busting things out so much we don't have enough time for critiquing each other's work.

MC: Politically, I ask am I developing my ideas in a vacuum, or are they shaped by larger ideas? My ideas are never only shaped only by me. We have a lot of friends who are organizers, we have a lot of friends who are teachers, people who we have relationships with are constantly informing our ideas. We'll have people over for a barbeque and then watch something, and then discuss it, and talk about how could this be better or how could this be used as a popular education tool, and we'll talk about how something won't work for communities of color, or for urban youth or whatever, so all of that acts as building blocks for developing political ideas.

JB: Most of the times I'm hit up by organization, but a lot of times I'll hit them up, because a lot of people are kind of shy, or afraid it will cost them too

JUSTICE for Oscar Grant!
JUSTICE for Gaza!

End Government Sponsored Murder in the Ghettos of Oakland and Palestine

DignidadRebelde.com

much money. Last Halloween a group of youth shut down the Immigration and Customs Enforcement (ICE) building. I had heard them talking about it, and offered to make a poster for that, and they were really excited. So I made a poster, printed 100 or so, and I gave them a bunch, made them forty picket signs. Most of the stuff I do is for an action or for fundraising tools. I mean it's nice to get paid for work, but I have a day job, so I have the freedom to just make stuff for actions or organizations that I think are cool and just give it away.

Do you think there is a need to develop tools to help us understand how our art works in the world, and how to make it more effective? Or does that undermine its value as art? How do you negotiate that tension between art and utility? In ten years would you be happy to be in the same place as you are now?

FR: I don't want to be doing the same thing in ten years. I don't think I can go into my forties and be juggling two jobs, it's so exhausting. I don't feel like I take care of myself; I'm getting really burnt out. I'm looking at ways to survive more off my art. You have to have different ways of hustling. I would like to figure out how we can teach more people, even doing

things like filming a workshop and putting it on-line. The learning component is important. That's a direction I would like to move in, and figure out how to be more sustainable in what we're doing.

MC: I think about it in terms of evaluation. I've been asking, "Is my work really making an impact?'" And then I've been taking a couple of steps back and wondering if I'm even asking the right questions. I see myself as an artist in the movement, in relations to other things. That question isn't isolated to me; it ties into organizing and other movement building things. That question can't be asked in a vacuum.

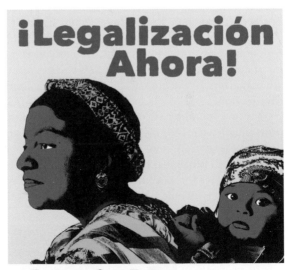

¡Legalización Ahora!

If Capital Can Cross Borders So Can We!

¡Si el capital puede cruzar las fronteras, tambien podemos nosotros!

www.DignidadRebelde.com

It has to be part of a larger idea, if we can say that we want to be moving towards social justice, we have to ask: how do we know we're going the right way? How do we know when to adjust? What are the models for alternative economies? These are big questions and as an artist I represent only one segment of the people who should be thinking about this stuff.

JB: Like I was saying earlier, we're in the baby steps of the next 500 years. I see us developing together, and this is my community now. There's a lot of our people around us who are organizers. We're gonna keep growing.

My love is in the handmade print. That's what I see myself doing ten years from now. I hope I can continue making radical graphics for movements. Along the way I would like to teach more youngsters. I want to pass this knowledge on, as it was passed on to me.

In all of your work, you can see an increasing influence and use of the computer. It has become more prominent, the work looks less hand drawn and more digitally processed. Why is that?

JB: I'm comfortable with computers, I've worked with them for a long time. It's always been a tool I've used. I think about that a lot, and sometimes I'm just being lazy or rushed. Sometimes things need a really immediate reaction, and then I generally use the computer. If things aren't so immediate, I can take my time and do stuff that is more hand-done, hand-drawn, the rubylith is hand-cut. I'd like to get back to this.

MC: All of my stuff starts hand-drawn. I think about how

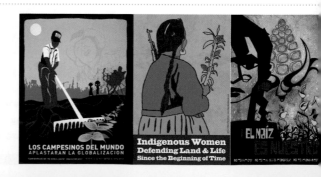

LOS CAMPESINOS DEL MUNDO
APLASTARAN LA GLOBALIZACION

Indigenous Women
Defending Land & Life
Since the Beginning of Time

¡EL MAÍZ

much articulation my wrist has, and how the technology that is in my wrist is way more sophisticated than the technology that is in a computer. Sometimes I'm like, "Damn, there's a lot of magic in my wrist." I still like to do my illustrations in pencil and ink. But I see the value in being able to work with colors on a computer. Sometimes I wonder what the difference is between hand-done printing and digital printing? I tend to gravitate towards traditional printmaking, thinking that it's better, but I wonder if it matters or if there should be more emphasis on just getting the work out there?

What about other influences outside of political graphics?

MC: I constantly get new influences. As a teenager I was a graf head, constantly going out and bombing buses, our crew was called Fuck Society. That's influenced me a lot. I also really like the lines of comic book drawings. I like to see how people approach their lines. I look at popular culture, I look at color schemes in sneakers. I think about that when working with youth, because that's what's resonating with youth right now. We've all been influenced by Indigenous art, stuff from Turtle Island, stuff from all over the Americas. Really old marks . . . we've all incorporated those marks into our work at different times.

JB: I also remember one time, when I first started making posters. I don't go wheat-pasting a lot, but I was part of the SF Print Collective in 2001 and 2002. We had a couple of poster campaigns going on, one was about homelessness. I made a poster, and it had a guy with a gun and a shopping cart on it, and it said at the top,

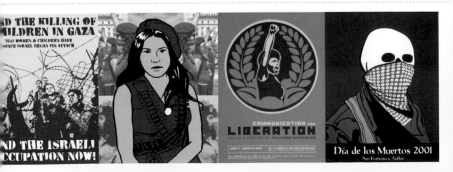

"How many people does it take to start a revolution?" and then at the bottom it said, "There's 15,000 homeless people in San Francisco, is that enough?" We were out putting different posters up on the street in the Haight, and some guy came up to us, and he was tripping out that we were putting up posters, he asked, "Are you guys the same ones who put up these posters about homelessness? Did you make that one about the people starting the revolution?" and I said, "Yeah, I was the one who made that." And he was like, "That's really fucking cool." He really vibed off that cause it was something he connected to. And it was cool he got to share that with me. That was the biggest one-on-one that I've ever had with anybody. That's who I make posters for, people who are working to smash the system.

For me, I'm really influenced by the psychedelic '60s art work, when I was in high school I read *The Electric Kool-Aid Acid Test*, and that was one of the primary reasons I moved to the Bay Area.

MC: He was chippie, a Chicano hippie!

JB: I was learning about psychedelic poster art and at the same time I had a deep undercurrent of Xicano politics and what was going on in my community. One of the big issues that you can look at in the "CARA" exhibition catalog is that there's a concept of what Chicano art is and was. It was very culturalist and it had a certain politics—it was low riders, the Chicano mural movement, and the Virgin de Guadalupe. But this didn't include all the other things that we were; we were supporters of the Palestinian movement, supporters of the African liberation movements, and it didn't have any of that. A lot of the art we make is really going against the stereotype of what Chicano art is supposed to be. We're not sticking to that one tradition. Chicano art shouldn't just be this one thing. ⑤

More information and images from the TTA can be found at:
TallerTupacAmaru.com
Favianna.com
DignidadRebelde.com

WHAT IF ALL YOU HAD WAS A SLINGSHOT TO DEFEND YOUR LIFE?

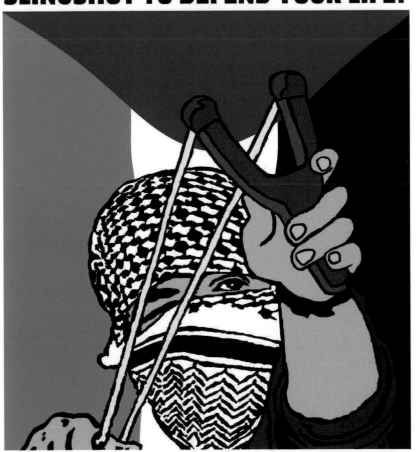

SOLIDARITY WITH PALESTINE

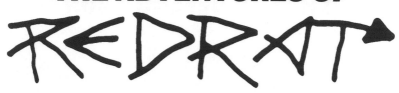

THE ADVENTURES OF REDRAT

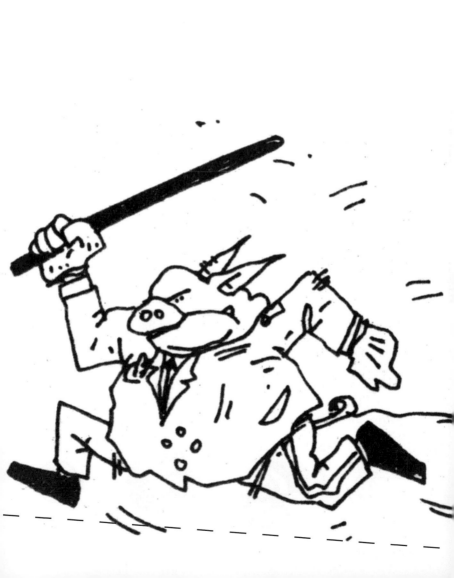

I n 1980 Johannes van de Weert published the first issue of *Red Rat*, a comic book about a hapless rodent who became caught up in the riots that surrounded the coronation of the Dutch queen in Amsterdam. Red Rat was something of a Dutch everyman. He was, at times, an office drone who joined the Basque resistance while on holiday, at other times a squatter or a travelling punk, and often just an outraged passerby.

Van de Weert was one of the progenitors of the Dutch punk scene. He sang in the band the Rondos, helped start the collective community center Huize Schoonderloo in Rotterdam, and was part of the collective that printed and produced the collective zine *Raket*, as well as many other cultural and political projects that that were humourous, confrontational, and biting.

Johannes van de Weert was interviewed in the Spring of 2010.

Red Rat first appeared in 1980. Can you tell us how this comic came to be? What were you thinking?

It was mostly the anger about the police violence during the riots on April 30, 1980—the day of the coronation of queen Beatrix—that initiated the first *Red Rat* comic. Other members

of the Rondos and I fought against the riot police that day in Amsterdam. The police used helicopters, firearms, and gas against the demonstrators. On the day itself there were rumors of people being clubbed to death by the police—it made quite an impression . . .

At the time we were living together—the Rondos and a few others—at Huize Schoonderloo in Rotterdam. We were just about to end the Rondos and we were working on the last two volumes of our fanzine *Raket* when I started *Red Rat* . . .

Red Rat appeared as your band the Rondos were ending, and the politics expressed are similar but the tone is totally different. The Rondos were strident and militant whereas Red Rat is oftentimes silly. Was this purposeful?

I don't think Red Rat himself was that silly—he lived in a silly and chaotic world and tried his best. He was trying to understand what the hell was going on in society and in the left-wing movement—which was most of the time silly and chaotic as well.

And yes of course it was nice to illustrate the stupidity of

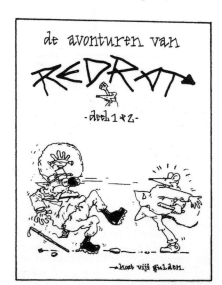

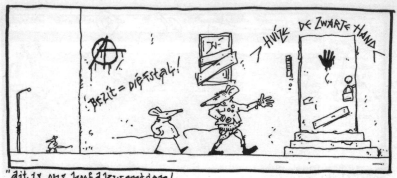

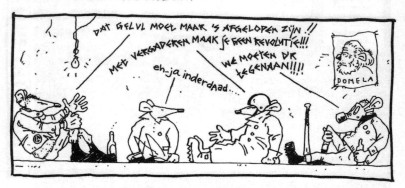

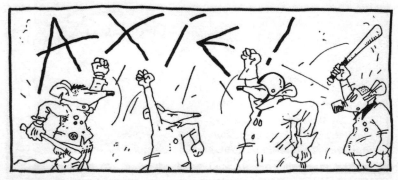

Translation (panel 1): "these are our headquarters!...." [graffiti: Property is Theft/>House of the Black Hand<] (2) It's time the bullshitting stops!—Meetings don't make revolutions!!—Time to engage!—eh, yeah, indeed... (3) AXION!

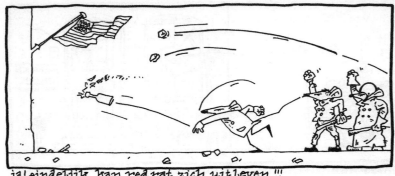

ja! eindelijk kan red rat zich uitleven!!!

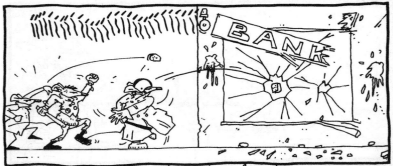

de éne spannende axie na de andere!....

red rat is zo entosiast dat-ie tot diep in de nacht doorwerkt – "fuck the system!" denkt-tie

(1) yes! finally red rat can have a go!! (2) one exciting axion after another! (3) red rat is so enthused that he keeps at it well into the night—"fuck the system!" he thinks . . .

the whole period in a comic like *Red Rat*. Lots of fun ... Playing in a punk band, making angry music is indeed a different thing, but at the time fun too ...

What was the inspiration behind the character of Red Rat? You have described him as "profoundly confused." He is a very sympathetic character, he's curious, nice, maybe a little naive, and easily outraged.

The best way to tell a story, I think, is to pretend you absolutely don't understand what is going on. . . Red Rat was desperately trying to sort out what was happening around him, and he got confused all the time but still he stayed true to himself. That is what made him sympathetic, I think. People recognized that. It is what we all try to do all the time.

These characteristics emerged while I was working on the comic—I never thought of this beforehand really—there was no

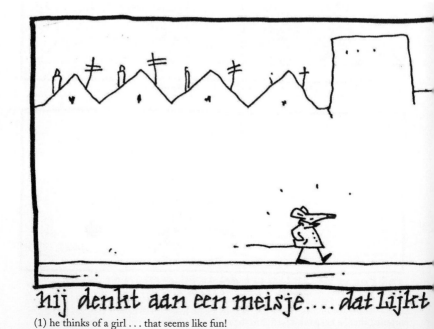

hij denkt aan een meisje.... dat lijkt

(1) he thinks of a girl . . . that seems like fun!

strategy, it just turned out that way. There was an urge to draw a comic on the events and I just went along with the story which was built out of observations I made on the street in that period.

Your comic style was very accomplished and consistent from the beginning. Did you have a love of comics? Had you drawn comics before?

Yes, I had done a few children's books in the same style (one of them was

best Leuk!

translated into English by Chumbawamba in 1987). But I wasn't much into comix at the time. I liked *Tintin* very much when I was a child, so that was a great influence, although I never thought of that when I made *Red Rat*. The great discovery at that time was *Krazy Kat* by George Herriman— absolutely brilliant, and in a way very much like *Red Rat*.

Each issue focuses in on a particular political issue. What were you hoping to accomplish by making comics about political struggles? Were you trying to use comics to reach an audience that might not be otherwise interested in such direct politics, or was Red Rat simply a mascot for the squatting scene?

I never hoped to accomplish a political goal. And when Red Rat turned into a mascot for the punk and squatting scene I stopped with the comic. That was not the aim. . . same as the Rondos. I was surprised at the time that so many people liked the character of Red Rat so much. The first part of *Red Rat* was stenciled in only 250 copies, but a short time after

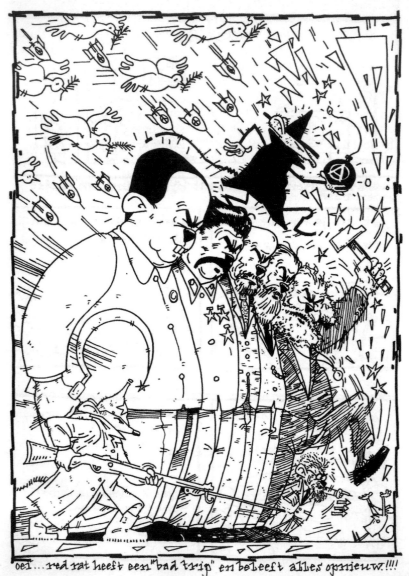

oei... red rat heeft een "bad trip" en beleeft alles opnieuw!!!!

(1) ouch . . . red rat has a bad trip and experiences everything all over again!!!

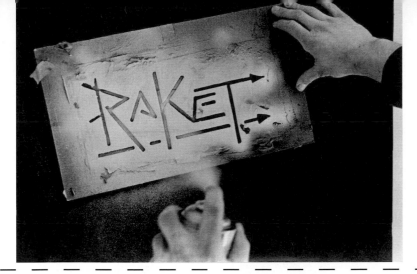

that we sold over 5,000 copies of *Red Rat* part 1 & 2. My main objective, if there was any, was to show, by doing it, that it was relatively easy to make your own comic (especially for young people) simply by drawing what you see around you in an uncomplicated style. DIY so to speak.

You used *Red Rat* as a springboard to relate stories of Nazis, the occupation, World War II, and the resistance. Can you tell us how these comics came together and what inspired you to make them?

I wanted to make a comparison of Nazi Germany in 1933 (so the beginning of National Socialist rule) and Europe at the present time (1981), which was heading to become something like the 'united police states.' And they were trying out some of the same nazi repression tactics, like the government-controlled press (*Schutzhaft*) and so on . . . Of course there was a great difference between 1933 and 1981, but as far as the counterinsurgency was involved a great many resemblances too. That was what I was trying to make clear. I used the photo album [style] to make it more personal.

Later in 1984 I published the comic *Uitverkoop!* [Sale!] about the rise of the Dutch National Socialist movement in Holland before World War II. That story was inspired by the stories of people we interviewed for *Rood Rotterdam*.

ROOD
ROTTERDAM
IN DE JAREN '30

UITGAVE
RAKET

time they ever told their story. With the book they all had something to show their families and friends. It was the first book published on 'ordinary' working class activists in Rotterdam in the '30s. We sold over 4,000 copies, mostly in Rotterdam.

Can you describe your zine *Raket*? How many issues did you make? What was the inspiration behind making the zine? I know that you wheat-pasted copies around Rotterdam. How many did you paste up? How long would they last on the street? Did it make an impact in Rotterdam?

In the beginning *Raket* was a poster we pasted on the walls of Rotterdam. The reactions to the first three posters were as expected, punks liked it and the police tried to peel it off the wall. Everybody could write or draw something for it. After three issues we got too much content, so we decided to make an A4 fanzine out of it. We made fourteen volumes all together. The first booklet (so no. 4) was twenty two pages in an edition of 350 copies. The

What was the *Rood Rotterdam* project and how did that came together?

Rood Rotterdam took three of us two years to make. We interviewed fifteen left-wing activists—men and women—who were active in anarchist, communist, and revolutionary groups and parties before the Second World War. For the book we used their stories, pictures, letters, poems, etc. . . . It was a lot of work but it was worth every inch of it.

All of them were very happy with the book as far as I know. For some of them it was the first

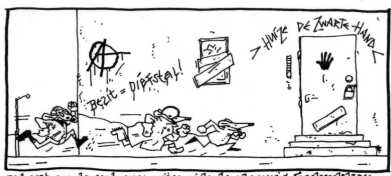

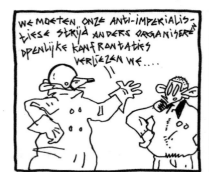

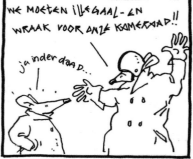

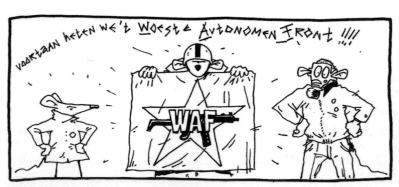

(1) red rat and the others are severely shaken . . . (2) "we have to rethink our anti-imperialistic tactics. we lose in open confrontations...." (3) "we have to go underground and avenge our comrade!!"—"yes indeed . . ." (4) "From now on we are the WILD AUTONOMOUS FRONT!!!!"

last one (no. 14) had 232 pages in an edition of 1,000 copies—all handmade. I guess it had become the most influential fanzine in Holland, so we stopped.

The Rondos, the Huize Schoonderloo project, and *Raket* zine all originated from you and some art school chums, correct? What brought you together? Were there certain artists you had an interest in? Were you interested in politics when you were younger or did politics find you by working on these projects? What was your art practice like before the Rondos?

We were all art students then (1977) and what we had in common was boredom because of the dullness of the atmosphere in the academy. So we did our own thing—odd projects and a band at first called "pull. . .use. . .destroy," and then later called the Rondos. We were mostly interested in music, not so much in art really. But we liked Dada a lot and felt related to their way of expressing themselves.

And, yes, I was interested in politics coming from a working class family. When I was seventeen years old I joined a small Marxist-Leninist group, mostly students, but did not like their amateurism (and they had no sense of humor). I was more into armed resistance and sympathized with the Red Army Faction in Germany . . . armed struggle seemed more appealing to me then handing out leaflets, the art I made related to this feeling.

In your biography of the Rondos, you wrote: "We did have our own ideas about art. First and foremost, it had to be worthless. That is to say art should not represent any financial value. Rather a thousand bad stencils than one

framed, unique but prohibitive pencil drawing with eternal value. To us, art was not a commodity, investment or status symbol. Art had to be reproducible, temporary, accessible to everyone and preferably exhibited in the streets. Our anti-art shaped our ideas, our discontent and our anti-authoritarian sentiments. Our work was anonymous and straightforward. And we couldn't appreciate the spiritual dimension of art, for the time-being." What do you think about this now?

Well, that is a different story. I believe that our statement on art back then still stands. The whole do it yourself feeling behind it is great and still accurate, especially for young people involved in a youth movement or underground subculture. And of course I still like to work this way when I am doing projects with other people, like the Rondos reissue and the new *Red Rat* comics. But for myself, when I am working in my own small studio upstairs it is different . . . Making art—if you want to call it that—which for me is mostly pencil-and-ink drawings on paper—is a religious or spiritual experience. In my work I relate to zen—as an effortless effort—a no-mind approach with no goals ahead, no expectations just see what comes. But that is personal (or unpersonal if

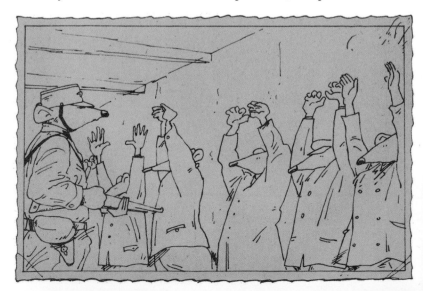

nou moet jij eens goed luisteren red RAT, ik vind
't echt heel leuk ALs je me de stAd LAAt zien, mAAr
je moet <u>niet</u> gaan LOpen pATSEN met de grootste,
hoogste enzo — en ook niet zónodig stoer doen en in-
druk proberen te MAKEN, en voor 't meisje betalen.
ALs je onzeker bent moet je dAt zeggen en NiET
overschreeuwen! als jij 't mannetje probeert uit te
hangen hoeft 't voor mij niet, SNAp je?...
't gaat er nou juist om dat we als ratten met
elkaar omgaan — man of vrouw!
de varkens proberen ONS in de rol te drukken van
werker of verzorgster — van bink of lekker wijf
om <u>hun</u> systeem in stand te houden!

wij moeten wijzer zijn jochie.....

(1) now listen up red rat, I think it's really nice if you show me the city, but you should
not boost with the largest and highest etc.—and don't act tough, try to impress, and pay
for the girl. If you are insecure just say so and don't overact! If you try to play the GUY
for me, I'm not interested, get it? It's about us getting along like rats, men and women.
The pigs try to push us into roles of worker or midwife, dude and babe to keep their
system in place! We should be smarter than that . . .

you like) and not something I would advertise.

The last comic I saw that you made was on the Dutch International Brigade in the Spanish Civil War. It seemed like your comic skill had really developed, not losing any of the rawness of the original *Red Rat*, but more detailed, sophisticated, and consistent. And then you stopped. Why?

I don't know if I really developed my skills—comparing *Red Rat* to *No Pasaran*. It was just a different way of working—like *Uitverkoop!* was different too. In 1987 *Raket* came to an end, but then I had already joined the Ex and worked on the *1936* singles and booklet about the Spanish Civil War. After that I had to stop with the Ex because I had to take care of my two small sons, Jan and Arie. I also became more and more interested in the esoteric, which was more what I was looking for . . .

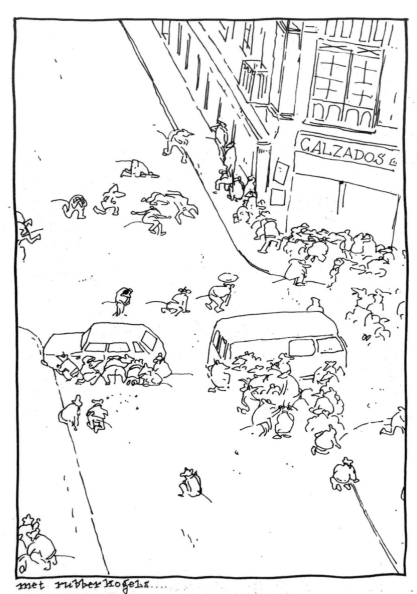

met rubber kogels....

(1) with rubber bullets ...

en traangas . . .

(4) and tear-gas . . .

I like being able to witness your jump from the Rondos to Huize Schoonderloo to *Raket* to *Red Rat*. All those projects were collective except *Red Rat*, which was individual and less serious. Was it liberating to work on your own?

Our collective has always been a mixture of collective and individual work ever since we started with the Rondos, *Raket*, Red Rock, etc. . . . Our individual work blended in with the collective projects. I made the *Red Rat* comix on my own but everybody helped with the printing, gathering, and distributing of the books.

What have you been up to for the last twenty years?

All sorts of things, but mostly studying the esoteric (which has nothing to do with new age whatsoever!) and I have devoted myself to art once again. And of course these two things are related . . . I have also been writing poetry, books, articles, and published some of it—still DIY style—and I have been giving lectures in esoteric Christendom, Taoism, Zen, and the Nordic tradition including the runes. Also on the occult background of national socialism.

I even sometimes made a comic and played along with the band The Bent Moustache. For now, I have just finished *Red Rat* parts 13 & 14. ⑤

The images and photos included here are from the Rondos archive. You can see more of the posters, covers, and comics at *Rondos.nl*.

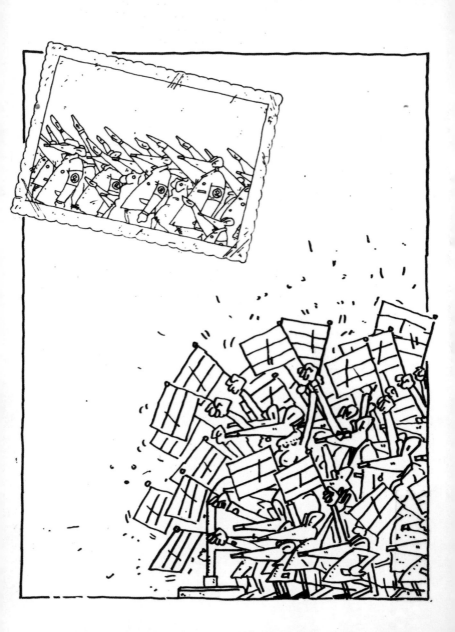

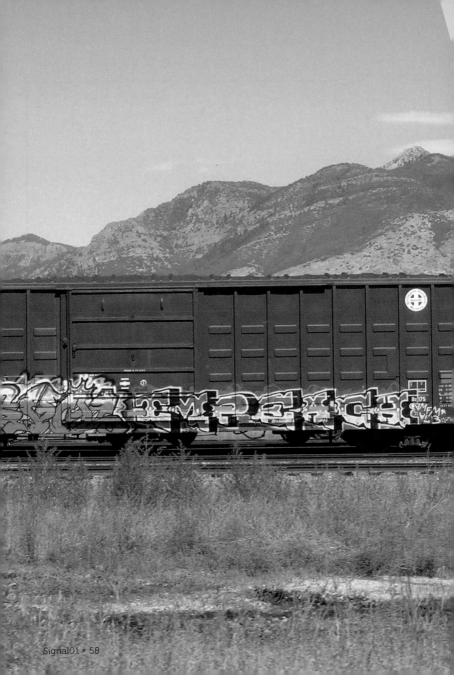

MPEACH is a graffiti writer from the U.S. Midwest. His painted freight trains criss-cross North America, carrying style and content. *IMPEACH, POVERTY, DEBT SLAVES, WE TORTURE,* and *BAILOUT.* He generally forgoes wild style letter forms for something a little more Wild West. In his own words, "The western letters make me think of bank robberies, gardens, home, common folk, and the Midwest." In our opinion, his voice is one of the most interesting and unique to rise out of the graffiti community in recent times.

HARD TRAVELIN' WITH IMPEACH

All quotes from IMPEACH except where noted.

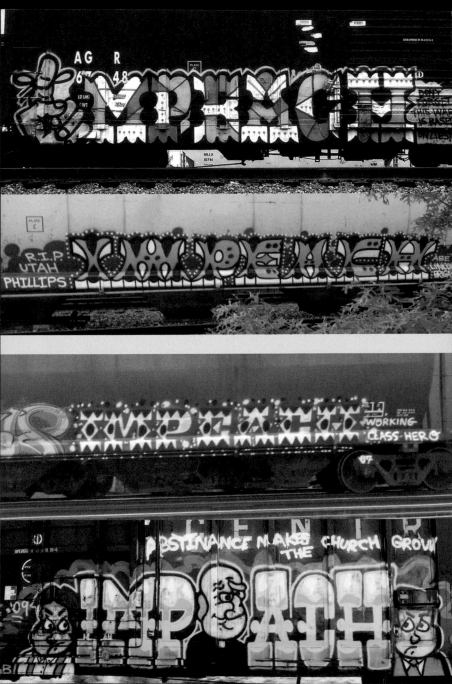

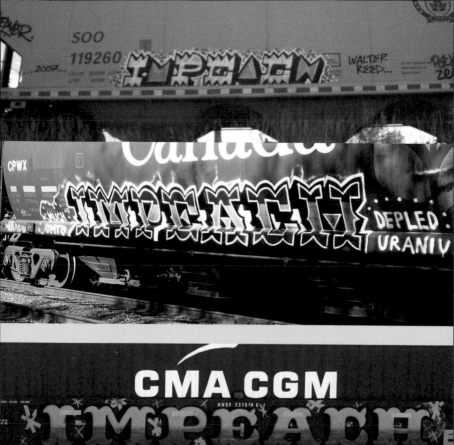

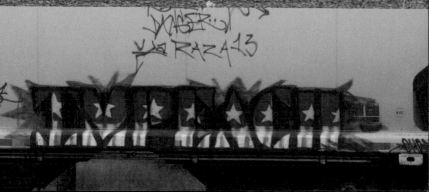

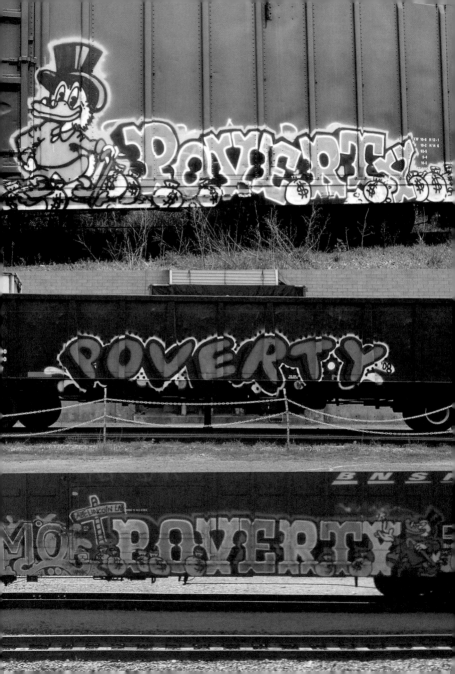

"The long memory is the most radical idea in this country. It is the loss of that long memory which deprives our people of that connective flow of thoughts and events that clarifies our vision, not of where we are going, but where we want to go."

—Utah Phillips (RIP)

This page spread, clockwise from top: p. kinne, Impeach, JAROH, quiet-silence, p. kinne, Brian Grenz, Brian Grenz, p. kinne, This Guy... (flickr.com/photos/tonedef999), Trent Call, p. kinne, Brian Grenz, Impeach.
Next page spread, clockwise from top: Impeach, p. kinne, Impeach, Impeach, SYN, Jason 'mightyquinninwky' Presser, Impeach, feck_aRt_post.

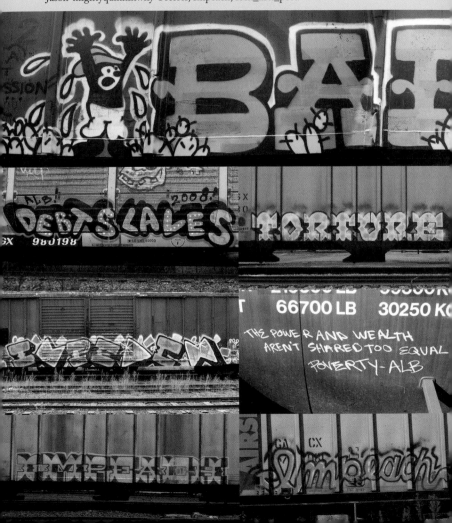

These cars go through major cities and to the smallest most rural towns including those of our NAFTA neighbors in Canada and Mexico. I can send a piece of me out there. Trains also have a possibility of lasting more than a couple years. Benching an older piece of graffiti from 1999 or something reeducates the work that is being done today. The accumulation of pieces over time can add up to a story, a theme, or a more explained idea.

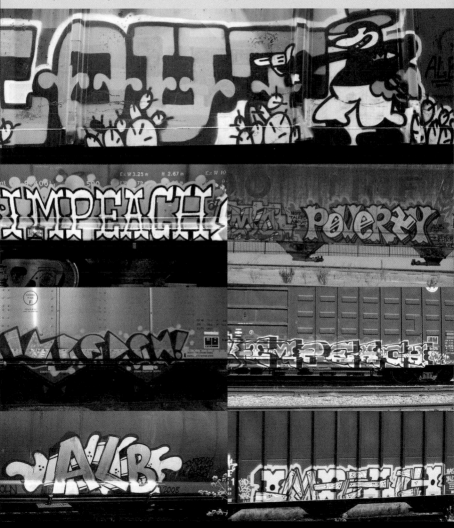

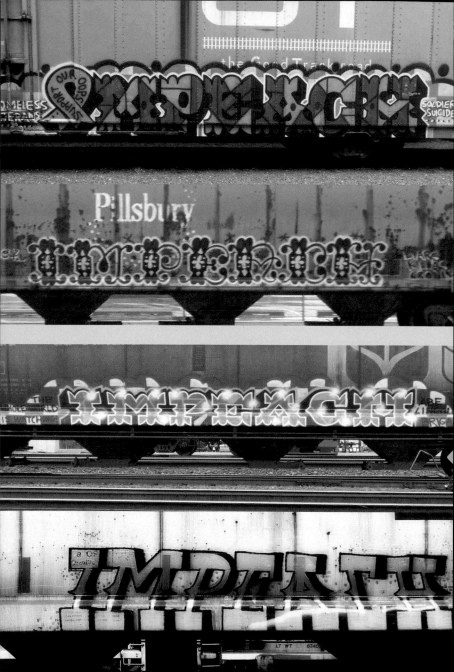

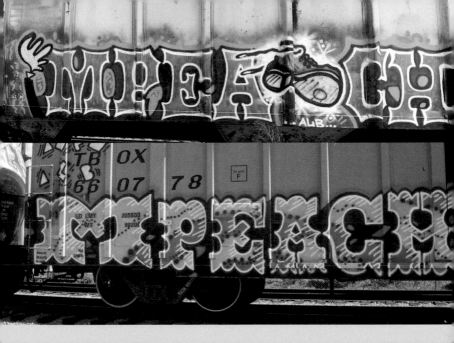

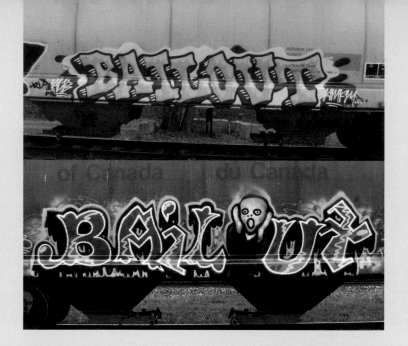

I do graffiti. It just so happens that I'm a politically focused person. I am IMPEACH, but I also mean to say IMPEACH. I wish to add to the conversation, listen, and argue. We are not getting anywhere riding the fence. Censorship comes only from the buff, getting gone over, or arrest. My ideas may be wrong, but I won't be able to know unless we discuss things openly, safely, and without censorship. Information about war, bailouts, torture, the federal reserve, and voices of dissent against them are suppressed. They deserve billboards to combat lies and untruths. I'm just joining the war of information and keeping track of history.

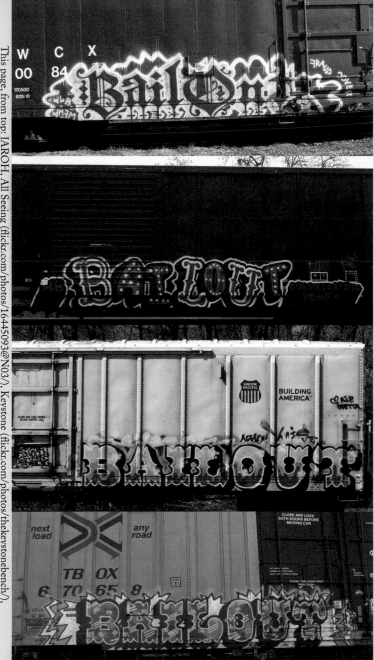

This page, from top: JAROH, All Seeing (flickr.com/photos/1644509@N03/), Keystone (flickr.com/photos/thekeystonebench/), JAROH. Previous page, from top: Impeach, Impeach, Impeach, JAROH.

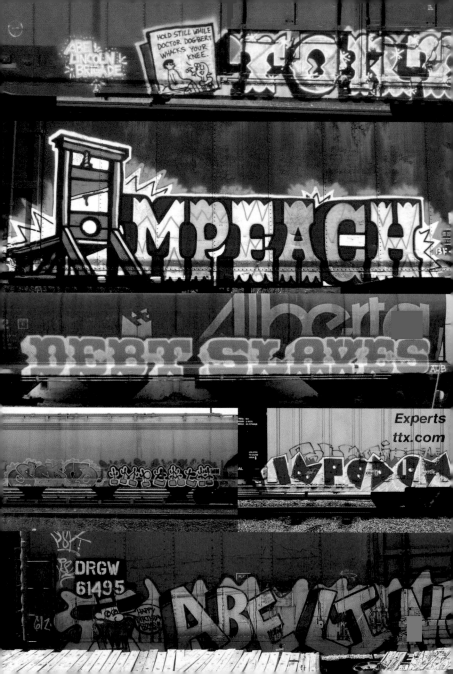

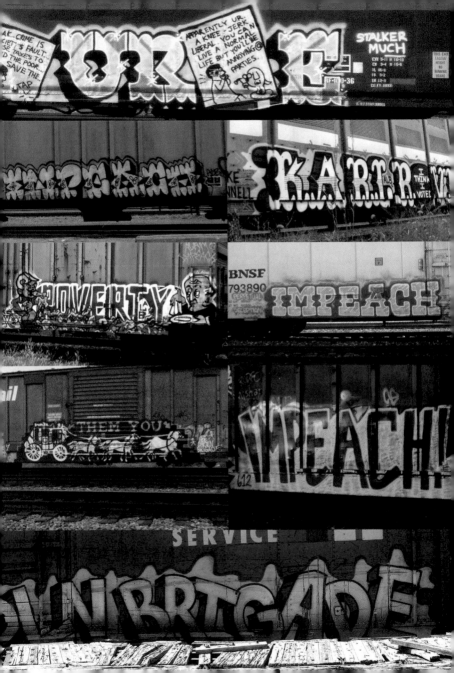

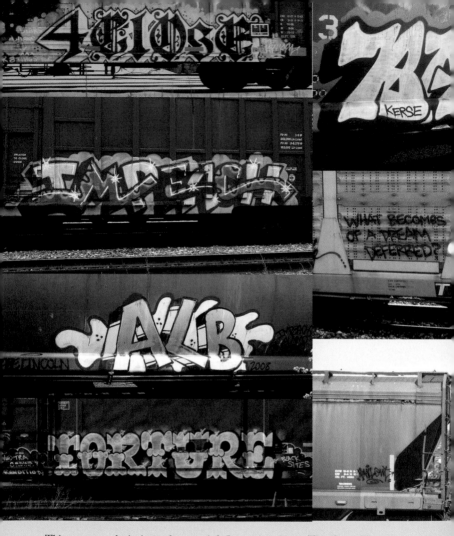

This page spread, clockwise from top left: Impeach, p. kinne, This Guy..., This Guy..., B. Brandt, Impeach, Impeach, Brian Grenz, Impeach, p. kinne, (OvO). Previous page spread, clockwise from top left: Impeach, Impeach, Hyphy McNightly (flickr.com/photos/theruener), Brian Grenz, JAROH, Impeach, Impeach, This Guy..., Impeach, p. kinne, Impeach, All Seeing.
Next page spread, clockwise from top right: Brian Grenz, Impeach, Impeach, Impeach, Impeach, Impeach.

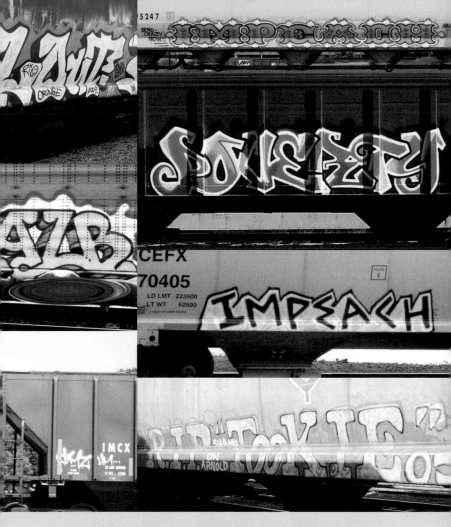

I am a romantic for the runaway from society: hobos, bums, unemployed, disillusioned veterans, and punks. Hitching the free ride outta here. I love the sound of them and the feel when they go close by you. To paint them you end up in lonely industrial spaces, rail yards with creeping noises, in a nature preserve, or corn field. These are all great places to be with a full sky of stars.

My own personal connection to the crew name ALB is to honor the efforts of the Abraham Lincoln Battalion that fought with the International Brigades against Fascism in Spain. Mussolini said, "Fascism should more appropriately be called Corporatism because it is a merger of state and corporate power." Today, we are seeing a global fascism in the form of the WTO, IMF, World Bank, Central Banks, Monsanto, and so on. The fight against fascism has not ended and it will take an international effort that each brigade will have to fight at their own home. IMPEACH is in solidarity with those who are doing small things and those yelling from the top of the mountain. Ⓢ

shout outs:
If you don't like light houses you suck! Piece to ALAMO. Remember—everyone has to do their laundry, MISHAP. Love for CHA and his family. High five to my Big Doug, KERSE. Are you there, SERVO? It's me Ras Impeach! Love for MT.

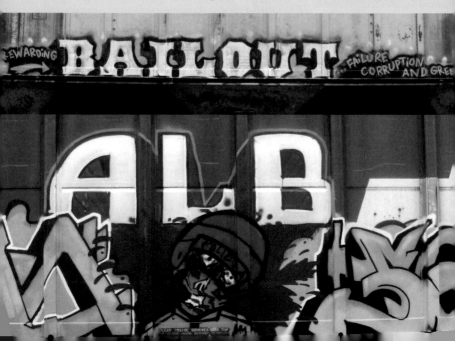

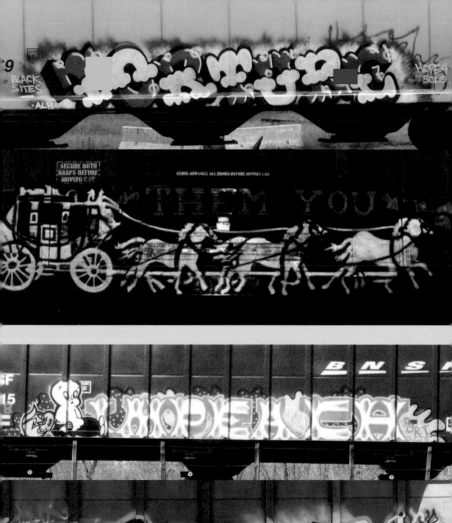
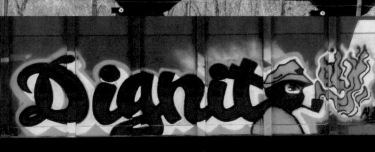

NAPOLI

EDIZIONI RL

7, Bᵈ DE STRASBOURG · PARIS, 10ᵉ

Concesión para la venta

EDITORIAL CLARIDAD

C. DE CORREO 736

BUENOS AIRES

Edición Especial de 500
ejemplares para

Tierra y libertad

Apartado Postal 10596
México 1, D. F.

GRUPO CULTURAL

TIERRA Y LIBERTAD

"RICARDO FLORES MAGON"

Estudios

Educación sexual, arte, ciencia, cultura General

Biblioteca TIERRA Y LIBERTAD

ELAN

BIBLIOTECA MUNDIAL

MEXICO

ZA DE MIRAVALLE NUM. 13

1925

ediciones

IMAN

ediciones

ediciones

HASTA LA VICTORIA SIEMPRE

MEXICO 68

THE GRAPHIC PRODUCTION OF A MOVEMENT

In 1968, there was a formidable social movement in Mexico City which staged frequent and large protests throughout the city. The protesters—including many students, but also workers, housewives, and intellectuals—demanded the abolition of repressive laws, the release of political prisoners, and the dismissal of a despised police chief. A summer of increasing confrontations between the protestors, right-wing paramilitary squads, and the police culminated in a massive demonstration on October 2nd. Over 10,000 people gathered in the Plaza de las Tres Culturas when government forces opened fire, killing and wounding hundreds of people and arresting thousands. Just ten days later, with the student movement on the defensive and the city under draconian lock-down, the XIX Summer Olympics began. One of the most enduring legacies of this movement is the incredible richness and immediacy of its graphics. These images, both leading up to and after the Olympics, were painted on banners, plastered on buses, and wheat-pasted on walls throughout the city.

The following is an interview with Felipe Hernandez Moreno, a printmaker in his late seventies and former member of the Mexican Student Movement. The interview was conducted by Santiago Armengod, contemporary Mexican printmaker and member of the Cordyceps Collective in Mexico City.

How did you first become interested in graphic and visual arts?

I had the chance to make it to the National School of Fine Arts in 1965. When I arrived I met the people that formed El Grupo 65, a group of students who were interested in politics. They wanted to change the study program of what then was Academia de San Carlos.[1]

What was the group's proposal?

The proposal was that they would give us a bachelor's degree, so it would be recognized as a professional degree. And this was achieved through our efforts, to the point that most of the members of the group were "allowed" to graduate with degrees. Obviously we were thinking that there were people that needed that degree to work: designers, graphic artists, etc.

Also one of our group's objectives was to work collectively, to lose our individualism. Artwork was created

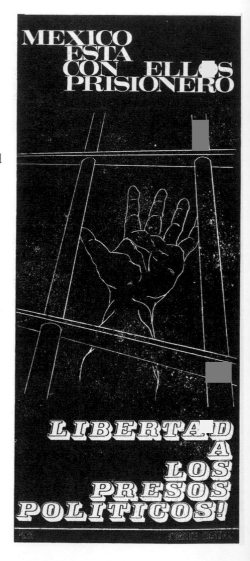

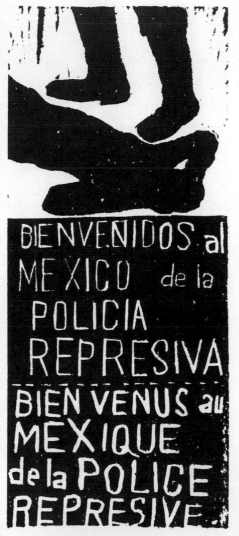

and it wasn't signed; we just presented it as Grupo 65, this was very important. There I learned to stop being a protagonist, we ended protagonism. Although I later became disillusioned, because lots of the people that started this critique returned to their original position as protagonists. But that's their problem, they passed this valuable knowledge to me and to me it was something extremely important.

So when I met those people I started to change my ideas and my concepts, though sometimes I found it hard to relate with my fellow group members because they were young and at the time I was thirty-four. I already had a small business, so I had a little money, and in their eyes I was bourgeois because I had that material wealth. It also could be that I manifested this, I often invited them out to eat because I saw that they had nothing to eat. And more than food we would go get snacks and drinks, because I always liked going to *cantinas*. It was a way for us to talk, and

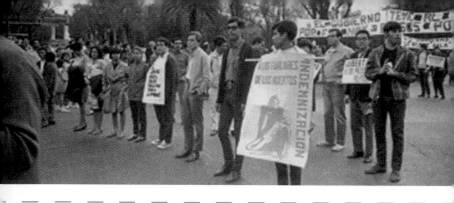

share ideas. Some of the people in the group were interested in politics from birth it seemed.

Do you think that graphics played a crucial role in the '68 Movement?

I think that graphics had a very important place because it was what made the movement educational. When the movement started, there was a lot of abstract talk on the issues and how those problems had developed, and graphics became a way to illustrate to people what those issues were.

How did the Propaganda Brigades start? How did you get involved?

When the student movements started, there were eight demands. We started making our images based on these. We made banners and posters,

articulating what we wanted and what we were fighting for. Then we had people from sociology and other faculties come and ask for graphic support. They would write out fliers and we tried to illustrate the message they sent to us. A poster should be shocking and should use few words, this way people don't have to stop to read it. The image should tell the message with a single blow, maybe without words at all.

So we started getting involved making images for ourselves in the art school, but also supporting other departments We used to print on *pegol* paper rolls, which was something similar to the paper used for gummed postage stamps. You would make it moist with a wet rag or saliva, and then, *bang*, you could paste it on city buses or cars that were going by.

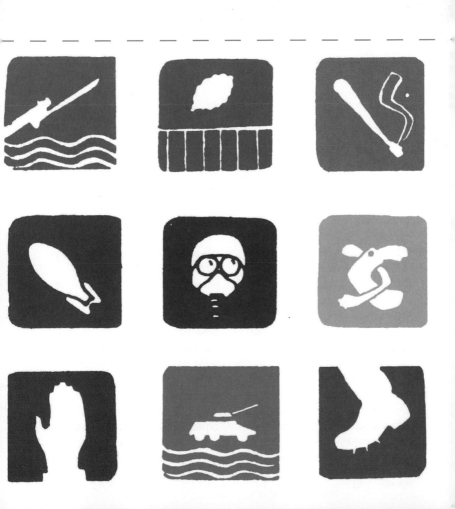

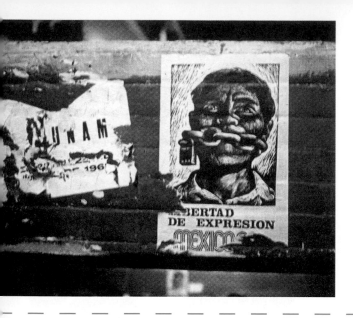

That was our way to contribute as propagandists. I got involved as an infantry brigadier. I would go around with a donation jar in the city buses and give out fliers that were dropped off by different faculties. We had a Strike Committee that was the link between the theoriticians, organizers, and us, the ones who created the images. That was how I started.

Was the imagery decided upon collectively?

No, it was individual. Each of us would come up with the ideas, or they ideas came at the moment of cutting the print

would be whatever came out. We generally used relief print-making and silk screening. We used linoleum since it was the fastest and most functional, and silk screening we would cut the stencils by hand out of film or paper. Printing needed to be fast for the graphics not to be dated; we had to keep up with all the news and circumstances. All of this was individual. Of course there were also teachers who had images which had already been used, for example Adolfo Mexiac's image about freedom of expression had been around for a long time. It was one of the most shocking images at that time

EXIGIMOS!
DESLINDE DE RESPONSABILIDADES

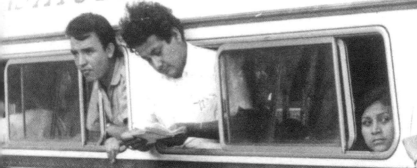

INSTITUTO POLITECNICO

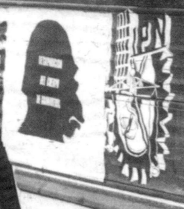

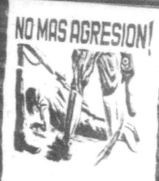

NO MAS AGRESION!

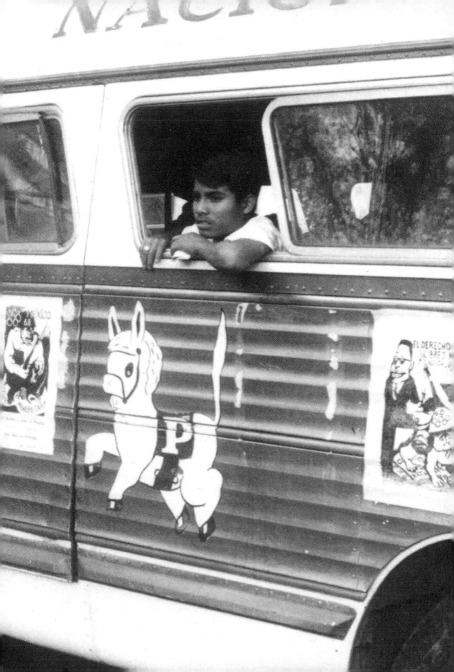

because of the context. There was another one by Francisco Becerril, another teacher, where the president, Díaz Ordaz, was turning into a gorilla.

It seems like there's a lot of repetition in the imagery and graphics done by different artists, i.e. gorilla-cops, vampire-politicians, bayonets, etc. Did the artists just borrow functional and effective graphic ideas from one another, or did the Strike Committee ask the brigades for certain representations?

No, the strike committee just asked for support in creating images. And each artist would create their own image, copying it or changing the figure a little bit, but keeping the same idea. We, as artists, called it "cultural parallelism."

Who was part of the brigades? Were they mostly students?

In San Carlos we were all students, there wasn't anything like someone coming and brainwashing us. As a matter of fact, our teachers would warn us,

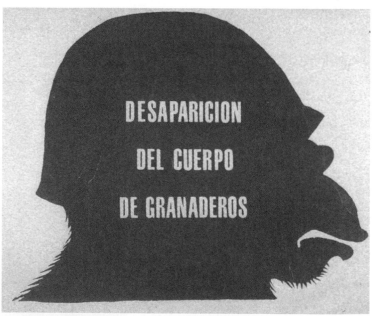

"Be really careful, take good care of yourselves, because these people aren't playing, this is something really serious." But it was us, the students, who were spontaneous. I don't know how the brigades in other faculties were constituted, but we were mostly all students.

Did more people join the brigades as time went by?

Yes, of course. The school workers joined. Also some students from the department which is now called Commercial Graphic Design. What was it called then? I think it was Advertisement Drawing, and they were more "bourgie"!

They still are...

(*Laughter*)

Was it mostly men or were there women?

There were women. Women generally worked in printing

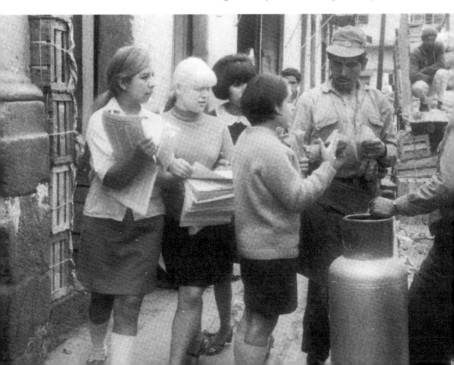

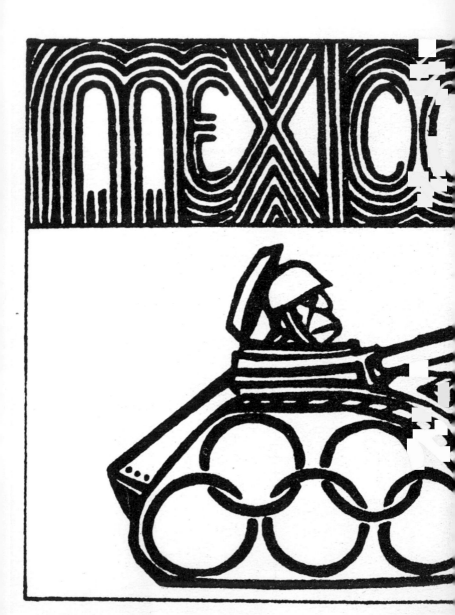

and creating images; they hardly ever went out in the streets with the brigades because it was really dangerous. We were half a block down from Palacio Nacional and the presidency, so the government kept a pretty close check of what we were up to. To even go on the city buses to give out fliers and pass the donation jar around, we had to do it really discretely, because we were so close to Palacio Nacional and we were being watched and we often saw the military patrolling around. So women hardly ever went out.

Were there sectors of Mexico City that the brigades mostly operated in?

Yeah, we mostly worked in markets and around factories. We would make flash protests, which consisted of gathering the most people we could when everyone from the factories or market was going out for lunch, and right then we would surround everyone with megaphones and we would pass out fliers. Our brigade was comprised of six people, and they generally had six people. We were organized in a way that if for some reason one of us got busted, and this is the truth, we wouldn't know more than our immediate boss, the rest of the organization we didn't

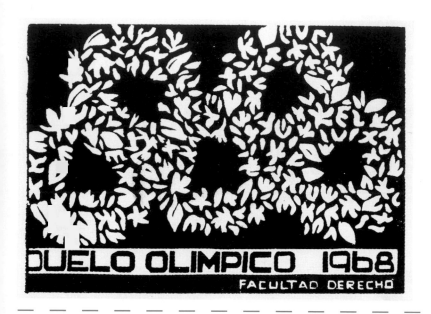

DUELO OLIMPICO 1968
FACULTAD DERECHO

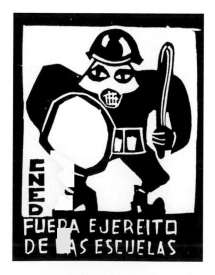

CNED
FUERA EJERCITO
DE LAS ESCUELAS

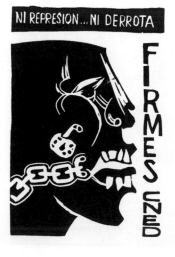

NI REPRESION... NI DERROTA

FIRMES CNED

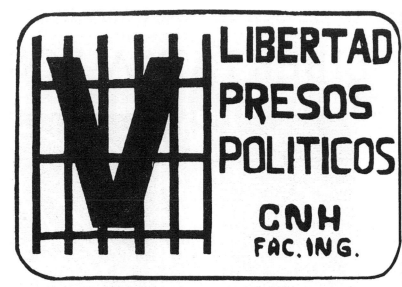

LIBERTAD
PRESOS
POLITICOS

CNH
FAC. ING.

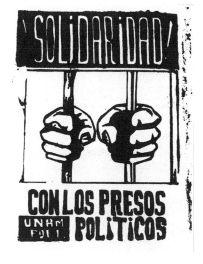

SOLIDARIDAD

CON LOS PRESOS
UNAM POLITICOS

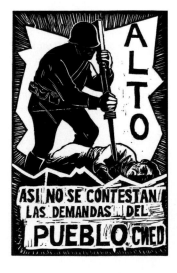

ALTO

ASI NO SE CONTESTAN
LAS DEMANDAS DEL
PUEBLO. CNED

know. Then only my boss knew his boss and so on all the way up to the top.

So the brigades not only created the posters but also went out to paste them up?

We had a rule that whoever printed the posters didn't do anything else at the time. Creating those posters was an illegal act, so if you were to engage in putting them up you would be committing two crimes. Meaning that if you were to get busted, it would be only for producing posters and nothing else. So we took turns printing and pasting.

Did each member of the brigade have a specific function?

Yeah, some of them would hand out fliers, some of us would go around with the donation jar, another one would be on the megaphone, and another one was on the lookout for cops and military. These were our jobs. We had a really hard experience working in PEMEX.[2] We were waiting in different spots outside the factory for the workers to come out when unidentified police vehicles started showing

up. We realized that some agents had arrived, it was easy to tell who they were, and we started running. We had been told that a brigade dedicated to confrontation with the police would be there to support us, but it turned out that the fucking brigade never showed up when things got tough. Later we complained to the people in PEMEX why they had left us there like that, not even a place to run into.

What was your printing schedule?

We didn't have a schedule, we just did what had to be done as it came up. So, if there was some sort of new agreement in the movement that needed to be publicized we would say "fuck it" and start working right then and there. We spent all our time at school printing. We were there Sundays, we ate there, we had breakfast and dinner there, always working like crazy. It was so much fucking work, there was never enough people.

How big were the print runs?

Generally the minimum was 100 prints. And the size of the print mattered too, because there

A LOS FAMILIARES DE LOS MUERTOS

INDEMNIZACION

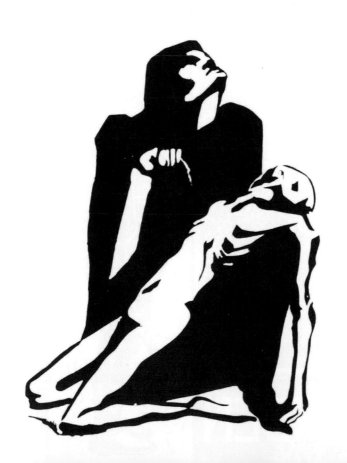

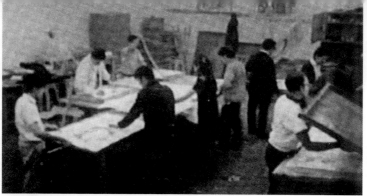

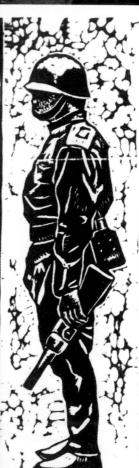

A LA

UNO

BANCO DE MEXICO

UNO

ORDEN

were prints the size of a whole large sheet of paper, and that makes it a little harder. Generally we printed one-colored prints, and we didn't really check the quality and registration, however they came out is what we used. I think that the maximum print run was 500, but just because we couldn't completely plaster the streets. (*Laughter*) Maybe if we would have had an offset printer, our runs would have been thousands, but we didn't. They were large runs, but at the same time short because of their function. But just imagine: Five different posters makes 2,500! Don't think that just because we had printed 500 of one design we wouldn't print the other designs. If we had to print eight designs we would print them. Generally the person who made the image printed his or her own prints. We were there from the start until we finished. Luckily lino lasts a long time, but if a plate was starting to deteriorate, it didn't matter, you just kept going.

Were all of the materials paid for by passing around the donation jar, or were there other ways to gather funds?

Everything was through donations. After asking for donations I would turn in my jar to the commission and they distributed it to the brigades. Sometimes we would take some money for a meal, because we had to eat somehow!

Around the world in the late 1960s, radicals and students started silk screening posters. In Mexico it seemed like relief printing was the preferred medium. Does this have do to do with the history of the medium in Mexico with groups like Carabina 30 30, the TGP (Taller de Grafica Popular), etc.?

No. While it is true that Mexico has a people's graphic and printmaking tradition that will make you shit your pants, the real advantage of relief printmaking is that it's the cheapest and fastest. Silk screening is expensive: inks, screens, stencils, all of that is much more expensive than the materials for relief printing.

What other graphic methods were used?

Like I said before, there were woodcuts, or work on metal

plates, but for the most part those were pieces that had been around before the '68 Movement. They just fit in perfectly. We also used the mimeograph to do our illustrated fliers.

Those fliers and *pegotes*[3] you printed on the mimeograph. How many did you print of them at the time?

Maybe 3,000 to 4,000 copies of a flier.

Were all of the posters destined to the streets or were there runs that were destined for something else? Were any of them destined to collections?

It was like everything else. You may think it was ego, but sometimes you make a piece and you want to keep it. Plus you knew how important it was. Grabbing one out of a hundred didn't do any harm, though if each of the twenty of us printing grabbed one, that makes only eighty left. There were even people who ripped them off the wall to keep them. Obviously the effort of printing was not to make a collection but for the message to be heard.

Were there also private workshops or collective workshops that were used for the poster production? I heard that Mexiac had provided his workshop in Coyoacán?

Yeah, all the people that were interested in the movement collaborated, including people that would do silk screening in artisan workshops. We would visit and ask them, "Is there a chance that we could print here?" And they would say, "Yes, of course." They would let us borrow their workshops and materials. All of this happened when there was too much pressure on the school, because we reached a point when the pressure on the school was really crushing and you could say that we had to go underground. There were even times when people from other faculties would come with their screens, we would burn them and they would go back to their faculties to print on their own. But you could say that San Carlos Academy and Esmeralda were the ones that nourished all of the other workshops. Also the TGP and the EDA (School of Fine Arts and Graphic Design).

Was there state repression on the workshops?

Yes. In San Carlos, the government took all of the mimeographs, broke all of the screens, and destroyed pretty much all of the production materials they could see. When there was this type of pressure is when we used other workshops.

Did you identify the perpetrators?

It was the army. Though later they were saying that it had been el MURO, the so-called University Revolutionary Movement, a right-wing confrontation group.

In these assaults on the workshops did they also physically hurt brigade members, or was it mostly materials and the space?

They did beat some people. When you had the bad luck of being there sleeping when the army showed up, you would get beaten. There were people who slept there almost

every night; you could say they lived there. They were the ones who were most vulnerable. Me? Only if they went looking for me at the cabaret. (*Laughter*)

Were there any connection with the poster production in other parts of the world? Like the Atelier Populaire in France, or the Vietnamese and Cuban posters?

People came from diverse places. And there were connections. Raul Cabellos even had a really cool Vietnamese poster collection. Around that time is when we first started to exchange ideas, as well as support each other's work and graphics, too.

What kind of role do you think culture and counter-culture play within social/political changes?

I think that counter-culture is one of the most important things that could exist. If counter-culture didn't exist, culture wouldn't exist, because we would only have directives. We get manipulated and controlled as it is; just imagine if counter-

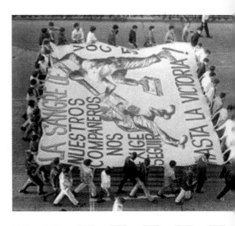

culture didn't exist. We would be robots or zombies. That's why it's important to have cultural workers, because we are people with life projects that we have to keep building, we have to continue changing the concepts, and keep changing the ideas. Because it's important to keep renewing and supporting the movements.

The system's strategies constantly mutate, and they certainly have changed since 1968. What strategies of struggle you used in '68 do you think could be applied today, and what suggestions do you have for the current social struggles?

One of the main contributions is to have a base for outreach, that's how you can support different social, cultural, political, peasant, and teachers organizations. That's how we should be organized, so we can keep up with this disinformation. We have to keep current and in communication.

Television is crushing, the media is crushing, so we need to have the same level of outreach. But any contribution is a great help. Before the interview we were talking about the problems in Chiapas, paramilitaries, etc. and you can listen to the radio or watch the TV and they will tell you Chiapas is wonderful! And you get there and realize that it's not true. They now let you move from one place to the other, but they keep close watch on what you are doing. And that is absolute truth. When our compañeras go to

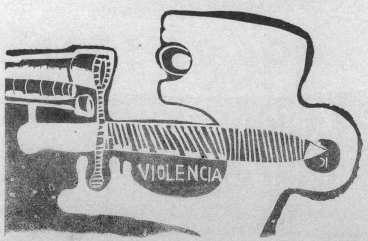

En la sociedad de clases

las revoluciones son inevitables

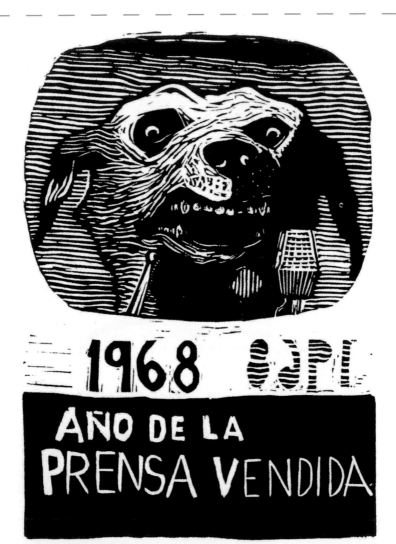

1968
AÑO DE LA
PRENSA VENDIDA.

the protests, they take their banners and they are so happy about it. But I tell them, "Watch it, compas, because they are monitoring you. You are already on the blacklist." (*Laughter*)

Do you still think that all of those experiences with the propaganda brigades are still useful tactics today?

Yes, absolutely. The knowledge is still being applied. I feel lucky to be part of the Metropolitan Artists and Culture Workers Convention, and we still fight with social movements that we know, or the ones that come and ask for our support, or we sometimes offer our collaboration with images and posters. We make portfolios, and they are not made just for the hell of it; they have a message, and a message with a context that is relevant to current political issues. We don't live outside of history just because images don't have an age. Images will continue to last through time. Those same gorillas and bayonets from 1968 could be updated to today. But we are not focused on history, we are current and we continue to use and invent even our own images. ⑤

The interview was conducted in Spanish and translated by Santiago Armengod. All images are care of the Collección Arnulfo Aquino.

Notes:
[1] San Carlos is part of the ENAP—Escuela Nacional de Artes Plasticas (National School of Fine Arts). After the 1970s it became the masters degree section, with a whole separate building from what its now the ENAP. They separated the school for two reasons: first due to the growing number of students and second, to isolate the radical artist community. The ENAP is now in Xochimilco (San Carlos is in downtown Mexico City) but they are both supposedly the same school, and part of Universidad Nacional Autónoma de México (UNAM).
[2] PEMEX is short for Petróleos Mexicanos, Mexico's nationalized oil company. They have various facilities throughßout Mexico City.
[3] Glue coated paper, similar to stamps.

ADVENTURE

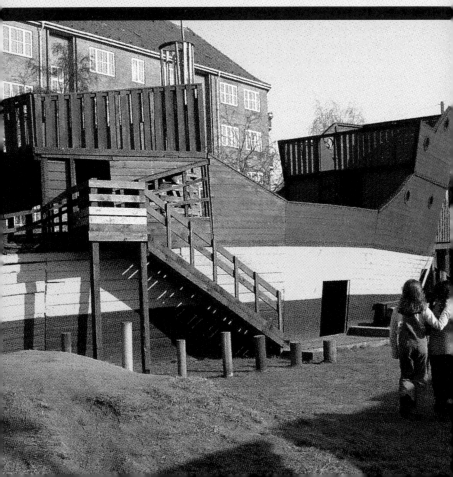

PLAYGROUNDS

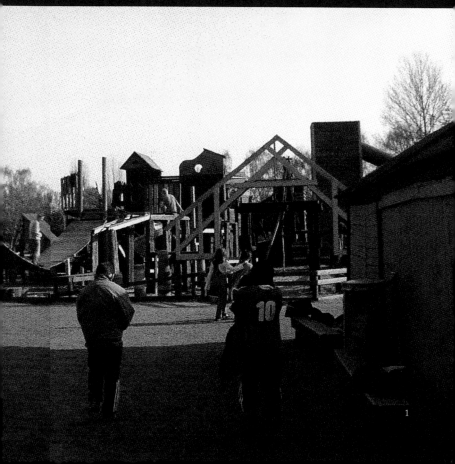

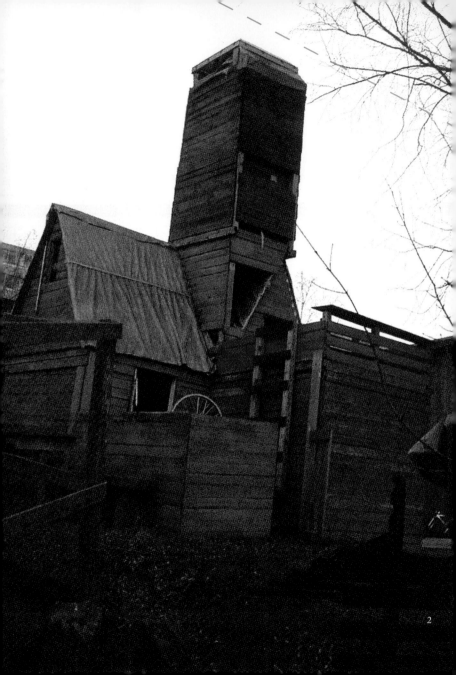

Children often want a wild space—a forgotten creek through the fence of the housing development, or a secret fort in the woods. Adventure playgrounds were created to deliver such space and freedom to young people in a dense urban environment. Adventure playgrounds vary widely in approach and organization, but follow the same common vision: using tools and cooperation youth create their own structures and landscapes. Danish landscape architect, Carl Theodor Sørensen, organized the first adventure playground in Copenhagen during the German occupation of World War II. Originally known as junk playgrounds, these projects were conceived as spaces where city children could, with waste material, create spaces that reflected their own vision.

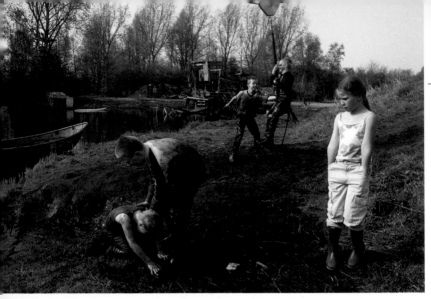

"The Emdrup playground was begun in 1943 by the Copenhagen Workers' Co-operative Housing Association after their architect, Mr. C.T. Sorensen, who had laid out many orthodox playgrounds had observed that children seemed to get more pleasure when they stole into the building sites and played with materials they found there. In spite of a daily average attendance of 200 children at Emdrup, and the 'difficult' children were specially catered for, it was found that 'the noise, screams, and fights found in dull playgrounds are absent, for the opportunities are so rich that children do not need to fight. . .'

"That there should be anything novel in simply providing facilities for the spontaneous, unorganized activities of childhood is an indication of how deeply rooted in our social behavior is the urge to control, direct and limit the flow of life. But when they get the chance, in the country, or where there are large gardens, woods or bits of waste land, what are children doing? Enclosing space, making caves, tents, dens, from old bricks, bits of wood and corrugated iron. Finding some corner which the adult world has passed over and making it their own."

—Colin Ward

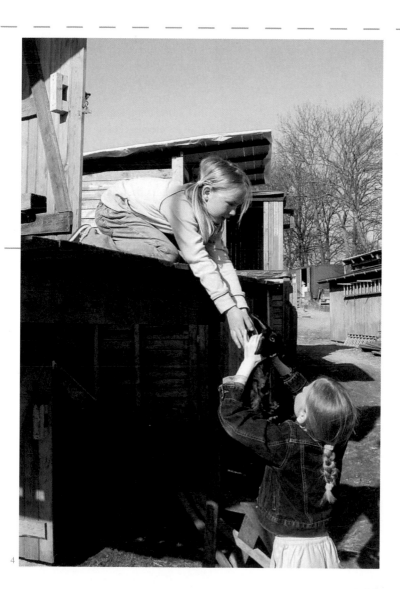

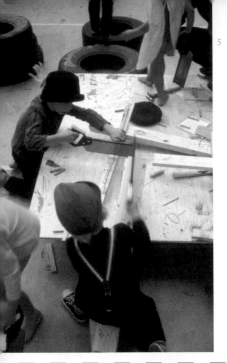

Adventure playgrounds pro-liferated in early 1950s England as a way for the population to reclaim derelict urban spaces. Children played happily in rubble heaps and bomb sites, and indeed seemed to prefer the informality of these forbidden zones to formal jungle gyms. Parents, activists, and park designers theorized that such nontraditional environments inspired creative and thought-ful play. Adventure playgrounds embodied the belief that the environments in which we rear our youth help mold the society

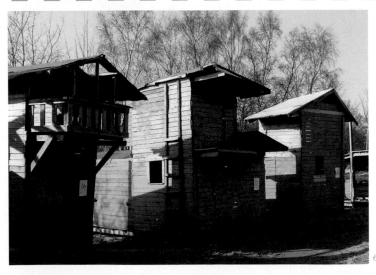

6

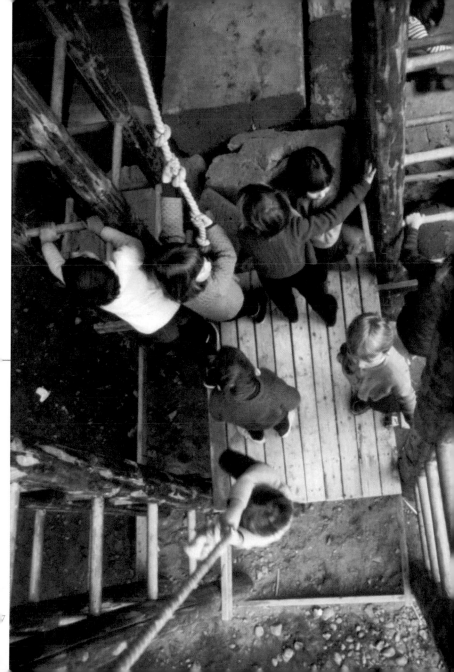

in which we live. The tightly prescribed range of activities provided by a traditional playgrounds prepare children to experience life as passive consumers, but the adventure playground allows a child to construct a world in her own image. These places allow children a rare sense of agency over their own environment. The philosophy of the adventure playground puts forbidden tools—hammers, nails, saws—directly into the hands of children who wield them to build and destroy cities of their imagination.

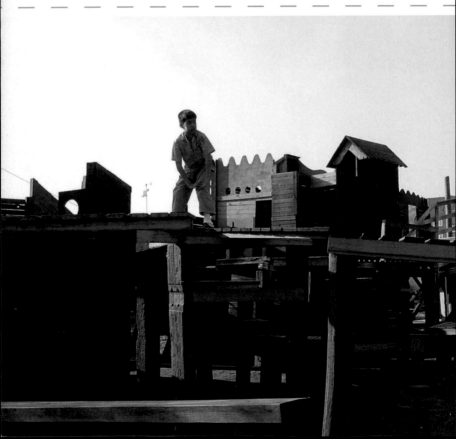

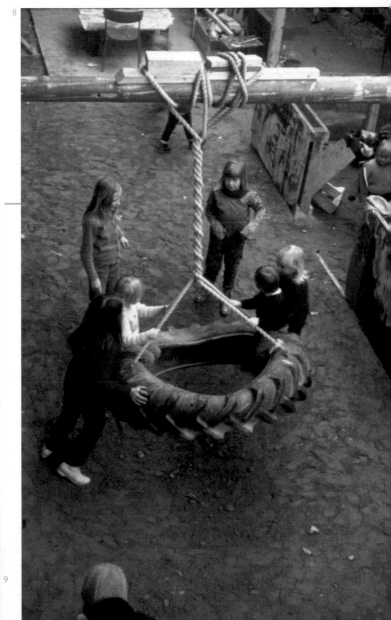

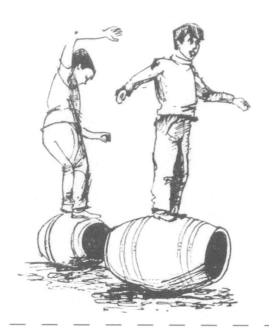

"Granting that childhood is playhood, how do we adults generally react to this fact? We ignore it. We forget all about it—because play, to us, is a waste of time. Hence we erect a large city school with many rooms and expensive apparatus for teaching; but more often than not, all we offer to the play instinct is a small concrete space . . . Noise and play go together, and it is best when they go together at the age of seven to fourteen. One could, with some truth, claim that the evils of civilization are due to the fact that no child has ever had enough play, or, to put it differently, every child has been hothoused into an adult, long before he has reached adulthood . . .

"Parents who have forgotten the yearnings of their childhood—forgotten how to play and how to fantasy—make poor parents. When a child has lost the ability to play, he is psychically dead and a danger to any child who comes in contact with him."
—A. S. Neill

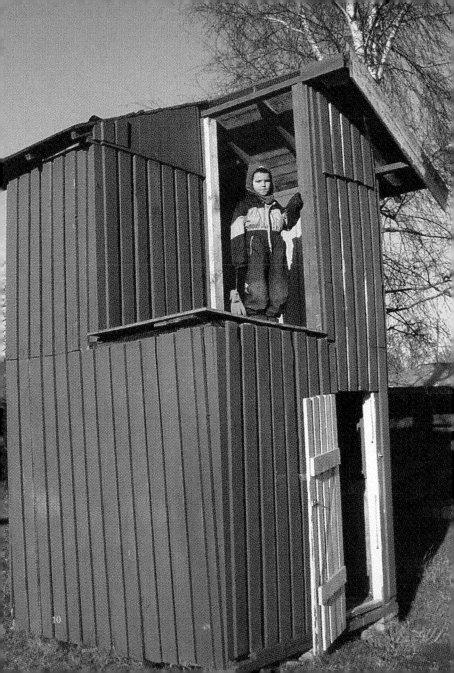

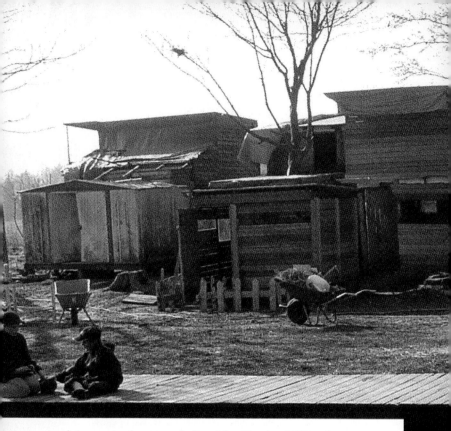

Adventure playgrounds flourished in the 1970s when many baby boomers began raising young children. Many survive (and thrive) throughout the world due to the ardent support of their advocates.

"Parents and the middle-aged, isolated in flats somewhere in the suburbs, were politically and existentially speaking done for, lured into the ideological traps of consumerism and the nuclear family. However, as an act of revolution-by-proxy the adults could provide their children with a free space, unfettered by urbanism. Thereby the children could be empowered with the possibility of a freedom from which capitalist indoctrination had cut the adults off."

—Lars Bang Larsen

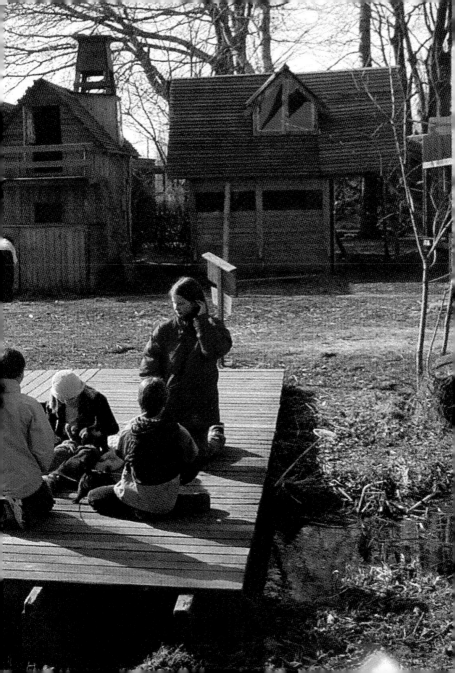

Sources:

Brett Bloom, "Political Art Activities in Denmark,"
in *Realizing the Impossible*, ed. Josh MacPhee
and Erik Reuland. (Oakland, CA: AK Press,
2007).

Paulo Freire, *Pedagogy of the Oppressed*. (New York:
Continuum Intl. Pub. Group, 1993).

A. S. Neill, *Summerhill: A Radical Approach to Child
Rearing*. (New York: Hart Publishing, 1960).

Colin Ward, "Adventure Playground: A Parable of
Anarchy," in *Anarchy: A Journal of Anarchist
Ideas*, no. 7, September 1961.

Drawings by Sheila Beskine (from *Anarchy* no. 7)

Photographs by
1, 2, 6, 9, 10, 11: YNKB (YNKB.dk. from *TEMA*
no. 6. All photos from Copenhagen. 1, 9, &
10 are taken at Bredegrund Byggelegeplads.
4 & 11 are taken at Rosendal. 2 is taken at
Grantoffen. 6 is taken at Bispevangen.)
4, 5, 7, 8: Palle Nielsen (photos taken at The Model
for a Qualitative Society, Moderna Museet,
Stockholm, 1968)
3, 12: Lia Sutton (Adventureplaygrounds.
hampshire.edu). 3 is taken at Kinderparadijs,
Purmerend, the Netherlands. 14 is taken at
Holtzwurm [Woodworm] Playground, Uster,
Switzerland.

12

"Education either functions as an instrument which is used to facilitate integration of the younger generation into the logic of the present system and bring about conformity or it becomes the practice of freedom, the means by which men and women deal critically and creatively with reality and discover how to participate in the transformation of their world." —Paulo Freire

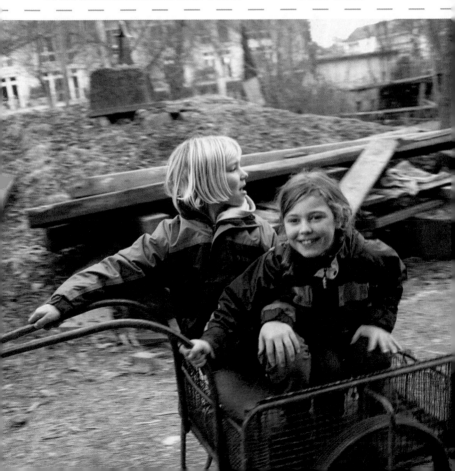

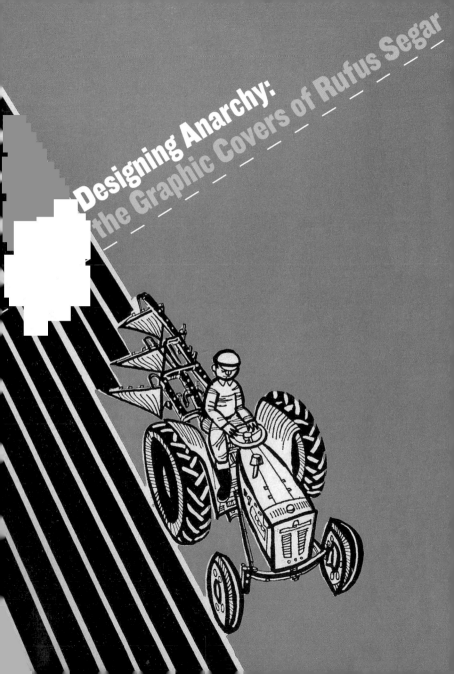

Designing Anarchy:
the Graphic Covers of Rufus Segar

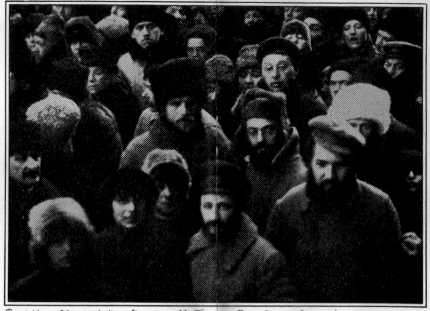

David Kohn, Olonetzki, Mark Mratchny, Olga Taratuta, Fanny Baron & Guyevski released from prison for one day to go to Kropotkin's funeral. Moscow 1921.

ANARCHY 81

TWO SHILLINGS OR THIRTY CENTS

Rufus Segar designed almost all of the 118 covers of *Anarchy: A Journal of Anarchist Ideas* during its ten-year run from 1961-1970. His work for *Anarchy* was unpaid but regular; fitted in around his paying design jobs. On two mornings in 2009, Dan Poyner met with Rufus and spoke with him about his work as a designer and illustrator.

Could you start by telling me a little bit about your background?

I was born in Ipswich in 1932, the second son of an itinerant pharmacist. I came from a lower middle class home and the things my parents read were *The Daily Express*, *The Daily Mirror*, and about four or five books that were in the house.

I can remember at about ten or twelve years old really wanting to be a cartoonist.

I was quite good at drawing, so in 1949 I was pushed into Liverpool Art School. They gave you a very good basic. It was life drawing, anatomy, perspective, composition; a very rounded pictorial

education. Then at the end of two years you had to choose whether you went into one of the two-year craft courses: painting, pottery, sculpture, illustration, theatre design, and so on. One of the tutors said to me, "You can draw bloody well. Don't go for the painting. Painting is all mad romantic tosh." Well, I really wanted to be a painter, but no, they said be an illustrator. And so the die was cast, I went into illustration.

You left art school in 1953. Did you get a job straight away?

After art school I had two jobs, the first was at a cardboard box factory in the sample department, and then in 1957 I got a job as an assistant designer at Horatio Myer & Co. Ltd. A three year stint there was the making of me. My job was eye opening, all aspects of design were thrown at me.

Next I got a job working at a top rank advertising agency, SH Benson. It was some sort of army, I felt like I was on a battleship or an aircraft carrier. Up top was the captain, and he was about sixty-five. He was running things on military principles. Below him there were six creative groups each run by a good old professional, someone about thirty to forty, with five or six assistant designers called visualizers. And down below that there was us all feverishly running about. At the end there were over 600 employees.

I soon realised that I wasn't really cut out for advertising work. Basically, advertising is a con. You have the idea and you sketch it out, then the client says, "Oh yeah, that's a good idea!" They take the idea from the designer and give it to the art buying department. Art buying would look at the idea and say, "Yes, so and so can draw that." They would then take it to an illustrator and ask, "How much for six of those in six different poses?" The illustrator would do the finished artwork, then you'd get a typographer to do the type. Eventually you'd pick up *Picture Post* and there's this full page advert, marvelous picture, slick typography, and where are you? You're nowhere, just an assistant in the system. I watched that for three years, just seeing how it worked, then I said, "It's not for me."

So you were working at SH Benson in 1961, the year that Colin Ward started editing *Anarchy* for Freedom Press. How did you meet Colin and start designing for him?

While at art school I'd shared a house with Harold Sculthorpe and others at 101 Upper Parliament Street. We were three couples, two students, and three children, and we lived there communally, sharing the running of the house for three years. All during that time we'd have meetings in the house. Harold had started the Liverpool Anarchist Group in 1949 or 1950. When I graduated in 1953, we moved down to London and shared a flat in Hackney. Soon after moving to London I married Sheila Bullard and we started a family, but we all still shared this flat in Hackney. There were too many of us there, so eventually Sheila and I moved to a flat in Pimlico.

At that time the London Anarchist Group ran the Malatesta Club near Oxford Circus where we'd go. And that was a meeting place and social space with chess playing and an eatery. They'd have speaker's corner on the weekends and maybe one or two pub meetings during the week and they also ran a weekly newspaper called *Freedom*. That's how I met Colin.

Colin was working at Freedom Press. He started the monthly *Anarchy* in 1961 as a foil to *Freedom*. He used an existing illustration by an artist called Michael Forman for the first cover then one

or two other people, including me, for the other early ones. I became the resident art director from number six onwards.

Would you meet up with Colin and find out what was needed for each issue?

No. I didn't meet Colin often, just one or two times about the covers. He'd just write me a postcard once a month with the info and post it in the mail. It would be enough time. I would just think about it for about a week, then call the block maker, Gee & Watson on Tuesday. So Tuesday to Wednesday, that twenty-four hours, was devoted to *Anarchy*. I'd deliver the cover that Wednesday afternoon. Everything else would be shelved until it was done.

Some covers would take almost a day to do, some covers were done in half an hour; a photograph, a caption, just physically drawn out, the picture here and the caption there. I'd do everything to artwork size, [typically 125–200 percent of the actual finished size of *Anarchy*] then off to Gee & Watson within the hour. Usually it was done and out on Wednesday, proofs to me and Colin and then blocks to Freedom Press on Friday.

It was a very old fashioned system. For an anarchist publication it was really ludicrous that you had me designing it, then you had the block maker, then you had the printer. The printer would print the insides and then he would send it off for the cover to be stitched on. There

were about six different organisations involved. It was only a 2,000 run, but it was a regular publication.

I work in a time where designers are taught to seek approval, to get "buy in" from all stakeholders before they proceed with an idea. Once you had the idea for that month's cover would you discuss it with Colin?

I'd send it straight to the block maker. Colin wouldn't see it. At no time did Colin ever say, "I don't like this, do this."

So you worked effectively alone, with complete freedom. Do you think that's because Colin wasn't interested in the cover?

No. Look at it from Colin's point of view. He was already working, *Anarchy* was on the side, and he would keep a correspondence going with his selected would-be contributors. He would keep milking the cow to get contributions. So when Colin had got enough words he would write his postcard to me. He was doing his editorial work—a one man band operation. Some months he'd be short on content, some months he'd be over. If he was over, it was as oppressive as being short. He was asking for 2,000 to

DIS
OBE
DIE
NCE

ANARCHY 14 A JOURNAL OF ANARCHIST IDE

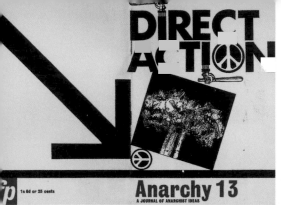

DIRECT ACTION

Anarchy 13
A JOURNAL OF ANARCHIST IDEAS
1s 6d or 25 cents
fp

ANARCHY 66
TWO SHILLINGS OR THIRTY CENTS

PROVO
fp

ANARCHY 55
2s /30c

John Hewetson
MUTUAL AID
AND
SOCIAL EVOLUTION
Richard Deeson
KROPOTKIN, MARY
AND DEWEY
John Woodcock I WAS ONE
OF THE
UNATTACHED

WHO ARE THE ANARCHISTS

Anarchy 12
A JOURNAL OF ANARCHIST IDEAS
fp 1s 6d or 25 cents

ANARCHY 72
STRIKE CITY, MISSISSIPPI

IN AN OPEN CITY ALL PEOPLE ARE FREE

ANARCHY 61
CREATIVE VANDALISM FOR 2 SHILLINGS OR 30 CENTS

3,000 words per contributor, or as much as they could spare. And that's how it went.

I've always respected Colin. He had very wide horizons, so in sowing his fields he got a very mixed crop. And only he could put it into baskets. Maybe the crime articles could wait another six months and he'd do a complete issue on crime. That's what he did: housing, crime, statelessness, police control, that sort of thing. These were solitary issues and they were easier to do covers for than the mixed ones. The mixed ones got mixed covers.

Of course, Colin didn't tell me until virtually the end of the run that he was always squirreling away 200 or 300 copies without covers, intending to produce them as volumes. So ultimately to him the cover was immaterial.

The covers change wildly, was that a deliberate decision on your part? Did you think that an anarchist publication should change itself at each available opportunity?

It was deliberate on my part not to repeat the previous one. Each one different. I saw no reason why they should be the same. In any case, it was a monthly delight. It's like a spoon full of sugar in black coffee. Each month, black coffee, black coffee, black coffee and then "oh!" this has got not just sugar but saccharine or cognac. It's an additive and really each one is a strident kick. But all the time being very disciplined about the ingredients.

The discipline, I think, was that everything had to work as a four inch block. But it wasn't a prison, it was a playground. Every month you have a square room, it's got four corners. But it's empty. And you put in what Colin puts in—a varied lot.

I mean, look what he's done with number 57: Buckminster Fuller, a sort of modern architect, Marx a good old faithful, crime, the law, Buber & Huxley is history, then jurisprudence. Three of the six are about the law and crime. You've got the makings of a criminal cover there. Marx and Buber & Huxley belong with each other and Bucky Fuller is out on a limb. So that cover should be about the law. Or you could

have made a composite solution, or you could make it mainly crime with Bucky Fuller on the side. Even now I can think of a criminal, lawyer, and hanging judge, that's crime. Bucky Fuller with a sort of globe on the side, looking. That would do. Any solution here had two or three others queuing up. Obvious and less obvious. So there was never any problem over what the covers were about.

Anarchy 57 solved itself. It was a mixed bag of stuff. "57 varieties, two shillings or thirty cents for six, *Anarchy* 57." It was just a take-off of Heinz Baked Beans. Six cans of baked beans, arrange it, and that's all there is in the cover. That is literally all there is.

The same you can say across the whole run. Overall what you see is the ingredients arranged in an empty white room every time. It's four corners. And you fill it with a flower, you put your hand in there, then out comes a bouquet! And you push that in somebody's nose and you say, "That's the solution. If you don't like it, clear off!"

The diversity can be put down to multiple sources resulting in multiple outputs. You've got two layers to this. I grew up studying newspaper illustrators, and then you've got graphic art, pop art, and all that sort of stuff in the 1950s and '60s. Then there are art exhibitions, culture as received by the London galleries, the painters and the sculptors. I just consumed that by going to exhibitions. My own taste, I incline rather to sculpture than to painting but I just take a broad view of it.

Let's talk about *Anarchy* 105. That was the only cover that you ever had rejected. What's the story behind that?

Robert Ollendorf was a Jewish refugee from Germany. He worked as a general practitioner and psychiatrist and was a partner in a practice with John Hewetson, who was one of the London anarchists. Ollendorf, who was an exponent of Reichian therapy, had an idea for a book—thirty-six sexual positions and the joy you can get out of them. So, he had a book which showed this couple—black-and-white photograph—in a position and then you had text by Ollendorf. It was a good book.

ANARCHY 48 IS ABOUT

PETER BROOK'S film of
LORD of the FLIES
from the novel by WILLIAM GOLDING

Colin decided that *Anarchy* 105 would be one big article about Wilhelm Reich and the sexual revolution written by Ollendorf. The cover that I did was mocking everyone. It was mocking the author, and Reich as well. It was a drawing of a woman and a man on a black background, taking the piss out of Ollendorf's book. He is saying, out of a bubble, the complete bibliography of Reich, sixty-four titles in German. And she is saying, "Orgasm schmorgasm! What does it matter so long as we have a good lay?"

I mean, the whole cover's a riot! Taking the piss out of Ollendorf, the pictures, and the subject. That's what *Anarchy* was and should have been about. But Ollendorf took against it. He put his foot down and said to Colin, "If you're going to publish this with Rufus's cover on, I'm not having it. I withdraw permission." Colin's response was, "Oh well, it's only one issue." So Colin did

ANARCHY 74
TWO SHILLINGS OR THIRTY CENTS

HOW REALISTIC IS ANARCHISM?

a typographic cover and it was published like that.

But the deepest irony of all was that ten years after *Anarchy* had finished, Colin was writing a column in *New Society* and was a bit hard pressed for something to write about, so he wrote up the incident. The art editor, Richard Hollis, who I knew, phoned me up and said, "Have you got a copy of that cover?" I said, "Absolutely." So I sent the cover off and they published it. And not only that, they sent me

£30! So that was an absolutely marvelous thing, after ten years of all that free work I got £30 for the suppressed cover.

You said before that you sent your work straight off to the block maker without anyone else having to see it first. Why then did you send this particular cover to the author?

I sent a proof to Ollendorf thinking he would like it! I mean silly fool me, I should not have bothered. Colin would

Workers' Control

Looking for a movement
Geoffrey Ostergaard Approaches to industrial democracy
Reg Wright The gang system in Coventry
James Lynch Workers' control in the building industry
Philip Holgate Aspects of syndicalism in Sweden, Spain, and America

anarchy 2
a journal of anarchist ideas

fp 1s 6d

THE WORLD OF PAUL GOODMAN

Reviews of COMMUNITAS, UTOPIAN ESSAYS
and GROWING UP ABSURD
Paul Goodman THE CHILDREN AND PSYCHOLOGY
Harold Drasdo THE CHARACTER BUILDERS
A. S. Neill SUMMERHILL vs. STANDARD EDUCATION

Anarchy II
A JOURNAL OF ANARCHIST IDEAS
1s 6d or 25 cents

THE WORK OF DAVID WILLS

ANARCHY 15 1s6d 25c
A JOURNAL OF ANARCHIST IDEAS

ANARCH
the Union

ANARCHY 33 1/6·25c

THE ANARCHISM OF ALEX COMFORT

COMMUNITY WORKSHOP

CHY 30 1/6 25c

why I won't vote

ANARCHY 37

ANARCH
The Union

ANARCHY 54 2s·30c

erich mühsam

martin buber

gustav landauer

ANARCHY 56 | 2s·30cents

IN A MAN'S WORLD

TWO SHILLINGS OR THE

ANAR
SYNANON & ANARCHISM

emma goldman

have seen it, I would have seen it, it would have been published and it would have gone down the river. I was a fool for thinking that Ollendorf deserved the compliment.

Did you encounter any other cases of censorship?

There was one, *Anarchy* 63. The one with Michelangelo's David on the front. The foreman of the shop that was stitching the covers on looked at it and said, "I can't pass this. I can't let my ladies see this, the ladies are objecting." So I said, "The lady that objects, please get her to phone me and I'll talk to her." And she never did! It was just him *in loco parentis* to the so-called ladies. He was the one objecting. So it nearly got censored, but didn't.

Anarchy 69, the one with the bare bottom, I thought would suffer the same fate because it's got a semi-nude lady on it. But it went through. But none of them were possibly objectionable. And I still don't apologize for anything!

I hadn't realised until just now that you've never seen all of the covers brought together like this before.

No, I never saw them *en masse*. I would just be working—one ahead and one behind. I had a very close focus on the thing. And then, looking at it en masse, you realise how very consistent the ingredients are. You've got the one strong image, the title of what it's about and then the sign off, *Anarchy*.

But you must remember, it's an empty room every month, regular four corners, window and a basement. And you would think about it for about a week and you come up with a simple solution.

Do you feel like you had artistic or design contemporaries who were also attempting to articulate politics aesthetically?

I suppose we had friends in the design and illustration world and friends in the London Anarchist Group but there wasn't any overlap. But for me, the pull between design and politics is strong— they're indivisible. The reason I stayed with *Anarchy* for the whole ten years was because I was dedicated to what Colin was doing. I

supported him. I was dipped in anarchy before I started designing the covers, then in anarchy that whole decade, and ever since. So the balance between what am I designing and who am I designing for answers itself. So it's a continuum.

A significant number of the first fifty issues have red and black covers on yellow stock. Did you make the decision to stick with this color combo and keep visual continuity with the covers, a house style so to speak?

Well, initially I was rationed to anything that worked on the yellow stock and so I'd do it black and red. But when you come to issue 41, the agricultural one, there's green and then on issue 69, pink for the belly. So occasionally I would use a distinct color that relates to the subject. But it was always black and one other color just for the impact of two high contrast colours. It was just as simple as that. I don't think that I ever used tones. It was a simple line work separation.

To begin with the character of *Anarchy* was the yellow stock, black and red printing. Then

once I got onto white stock I became be more inclined to specify colours.

You were working throughout the 1960s and '70s, but you were out of step with current design trends in many ways. There is little influence of psychedelia or new youth culture trends in the covers. At the time did you feel like you were looking backwards or forwards? Trying to chart new territory?

I don't think I was trying to chart new territory, or looking backwards or forwards, I was looking at what Colin was doing. I'd get a list of the articles, and I'd have to be completely focused on *now*! Now was the issue, you didn't look back to last week or forward to next, just concentrate on what you're doing and do it as best you can. Get it in, concentrate, boil it up, stick it down and send it to GM Watson on Thursday. You did a half day or a day, really at it, and you put your chin on the line and you *did it*. No future. No past. It was do the job that minute.

You were blowing up halftones and montaging elements, which

PLAYING AT

predates the xerox style of the 1970s and '80s, what was your process and your intention?

Well, that's really about what you do with your visual elements. Blowing up multiple images, particularly typography. Really enjoy your halftones. All that was grist for the mill in the '60s and '70s. I pushed that because I could see what graphic design was about. You take the thing and you blow it up until you could see what was going on, then cut a piece out and stick it down. Put it across, something big, something exciting.

So after ten years of *Anarchy*, how did it all end?

Colin lost interest when he got to volume ten. There was a change in management style and in size, format, and technique, too. All the time I'd worked with Colin, I'd worked on my own. But at this point it changed. The new lot who took over asked, "Will you keep on doing the covers?" and I said yes. So I did four or five covers for them, but inside, instead of just texts like Colin had run it, anything went. They also changed what was Colin's

ANARCHY 51 ANARCHY 51
2s. 2s.
30c. 30c.

notion of what an issue of *Anarchy* should be about. Three, four, five, or six articles on a theme became a general mish-mash and it just disintegrated. It was really too many cooks spoilt the broth. In the end I lost patience with it. I said, "Well, obviously you can do what you like inside, and now you can do what you like on the cover," and I dropped it. I just wasn't interested anymore.

Looking back, there were times when I thought, "What's going on? We're supposed to be anarchists putting the world to rights, and all we're doing is producing this magazine." But Colin did a good job. We're talking about fifty articles a year, times ten. That's around 500 bloody good articles on social and anarchist history. But who cares about all that? Although, here we are in 2009 talking about *Anarchy*. And I suppose even after nearly forty years, my wife Sheila and I are still anarchists, although for people to say so in their seventies seems rather peculiar. But there you are. Ⓢ

PAPER POLITICS:
SOCIALLY ENGAGED PRINTMAKING TODAY

Josh MacPhee, ed.

978-1-60486-090-0

$24.95

Paper Politics: Socially Engaged Printmaking Today is a major collection of contemporary politically and socially engaged printmaking. This full color book showcases print art that uses themes of social justice and global equity to engage community members in political conversation. Based on an art exhibition which has traveled to a dozen cities in North America, *Paper Politics* features artwork by over 200 international artists; an eclectic collection of work by both activist and non-activist printmakers who have felt the need to respond to the monumental trends and events of our times.

Paper Politics presents a breathtaking tour of the many modalities of printing by hand: relief, intaglio, lithography, serigraph, collagraph, monotype, and photography. In addition to these techniques, included are more traditional media used to convey political thought, finely crafted stencils and silk-screens intended for wheat pasting in the street. Artists range from the well established (Sue Coe, Swoon, Carlos Cortez) to the up-and-coming (Favianna Rodriguez, Chris Stain, Nicole Schulman), from street artists (BORF, You Are Beautiful) to rock poster makers (EMEK, Bughouse).

Praise:
"Let's face it, most collections of activist art suck. Either esthetic concerns are front and center and the politics that motivate such creation are pushed to the margin, or politics prevail and artistic quality is an afterthought. With the heart of an activist and the eye of an artist, MacPhee miraculously manages to do justice to both. *Paper Politics* is singularly impressive."

—Stephen Duncombe, author of *Dream: Re-Imagining Progressive Politics in an Age of Fantasy*

FRIENDS OF

PM

In the two years since its founding—and on a mere shoestring—PM Press has risen to the formidable challenge of publishing and distributing knowledge and entertainment for the struggles ahead. With over 40 releases in 2009, we have published an impressive and stimulating array of literature, art, music, politics, and culture. Using every available medium, we've succeeded in connecting those hungry for ideas and information to those putting them into practice.

Friends of PM allows you to directly help impact, amplify, and revitalize the discourse and actions of radical writers, filmmakers, and artists. It provides us with a stable foundation from which we can build upon our early successes and provides a much-needed subsidy for the materials that can't necessarily pay their own way. You can help make that happen—and receive every new title automatically delivered to your door once a month—by joining as a Friend of PM Press. Here are your options:

- $25 a month: Get all books and pamphlets plus 50% discount on all webstore purchases.
- $25 a month: Get all CDs and DVDs plus 50% discount on all webstore purchases.
- $40 a month: Get all PM Press releases plus 50% discount on all webstore purchases
- $100 a month: Superstar—Everything plus PM merchandise, free downloads, and 50% discount on all webstore purchases.

For those who can't afford $25 or more a month, we're introducing Sustainer Rates at $15, $10 and $5. Sustainers get a free PM Press t-shirt and a 50% discount on all purchases from our website.

Just go to **WWW.PMPRESS.ORG** to sign up. Your card will be billed once a month, until you tell us to stop. Or until our efforts succeed in bringing the revolution around. Or the financial meltdown of Capital makes plastic redundant. Whichever comes first.

PM PM PRESS was founded at the end of 2007 by a small collection of folks with decades of publishing, media, and organizing experience. PM co-founder Ramsey Kanaan started AK Press as a young teenager in Scotland almost 30 years ago and, together with his fellow PM Press coconspirators, has published and distributed hundreds of books, pamphlets, CDs, and DVDs. Members of PM have founded enduring book fairs, spearheaded victorious tenant organizing campaigns, and worked closely with bookstores, academic conferences, and even rock bands to deliver political and challenging ideas to all walks of life. We're old enough to know what we're doing and young enough to know what's at stake.

We seek to create radical and stimulating fiction and nonfiction books, pamphlets, t-shirts, visual and audio materials to entertain, educate and inspire you. We aim to distribute these through every available channel with every available technology - whether that means you are seeing anarchist classics at our bookfair stalls; reading our latest vegan cookbook at the café; downloading geeky fiction e-books; or digging new music and timely videos from our website.

PM PRESS is always on the lookout for talented and skilled volunteers, artists, activists and writers to work with. If you have a great idea for a project or can contribute in some way, please get in touch.

PM PRESS
PO Box 23912
Oakland CA 94623
510-658-3906
www.pmpress.org